DIVAS, DAMES & D●LLS

K. A. Fitzgerald

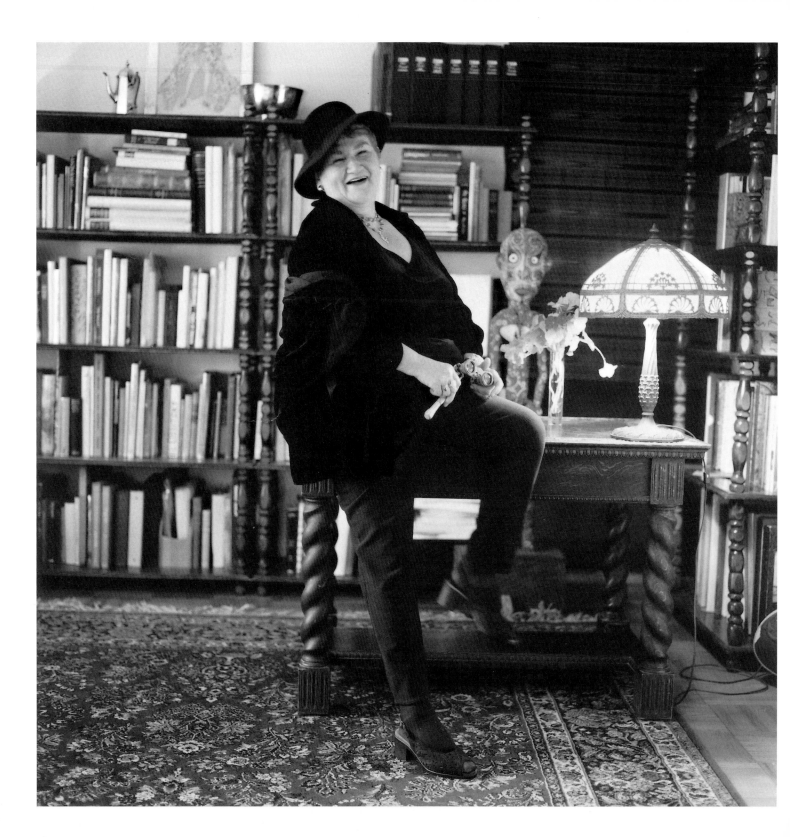

DIVAS, DAMES & DOLLS

A CELEBRATION OF THE FEMALE SPIRIT

KATHLEEN FITZGERALD

d

Hill Street Press
Athens, Georgia

A HILL STREET PRESS BOOK

Published in the United States of America by
Hill Street Press LLC
191 East Broad Street, Suite 209
Athens, Georgia 30601-2848 USA
706-613-7200
info@hillstreetpress.com
www.hillstreetpress.com

Hill Street Press is committed to preserving the written word.
Every effort is made to print books on acid-free paper with a significant amount of post-consumer recycled content.

Hill Street Press books are available in bulk purchase and customized editions to institutions and corporate accounts.
Please contact us for more information.

Text and cover design by Beth Kosuk

"The Quilt" Copyright 2001 Adela Roatcap

Printed in the United States of America

Library of Congress Cataloging-in-Publication Data

Fitzgerald, Kathleen, 1946-
 Divas, dames & dolls : a celebration of the female spirit / by Kathleen
Fitzgerald.
 p. cm.
 ISBN 1-58818-104-9 (alk. paper)
 1. Photography of women. 2. Fitzgerald, Kathleen, 1946- 3.
Women--Social
conditions. I. Title: Divas, dames, and dolls. II. Title.
 TR681.W6F54 2005
 779'.24'092--dc22

 2004018369

ISBN # 1-58818-104-9

10 9 8 7 6 5 4 3 2 1
First printing

Dedication

This book is a thank-you to my mother, who never had a chance
to fully live her life; a love letter to my daughters, who are experiencing
the challenges and joys that transform young women;
and a tribute to women with spirit, who are an inspiration to us all.

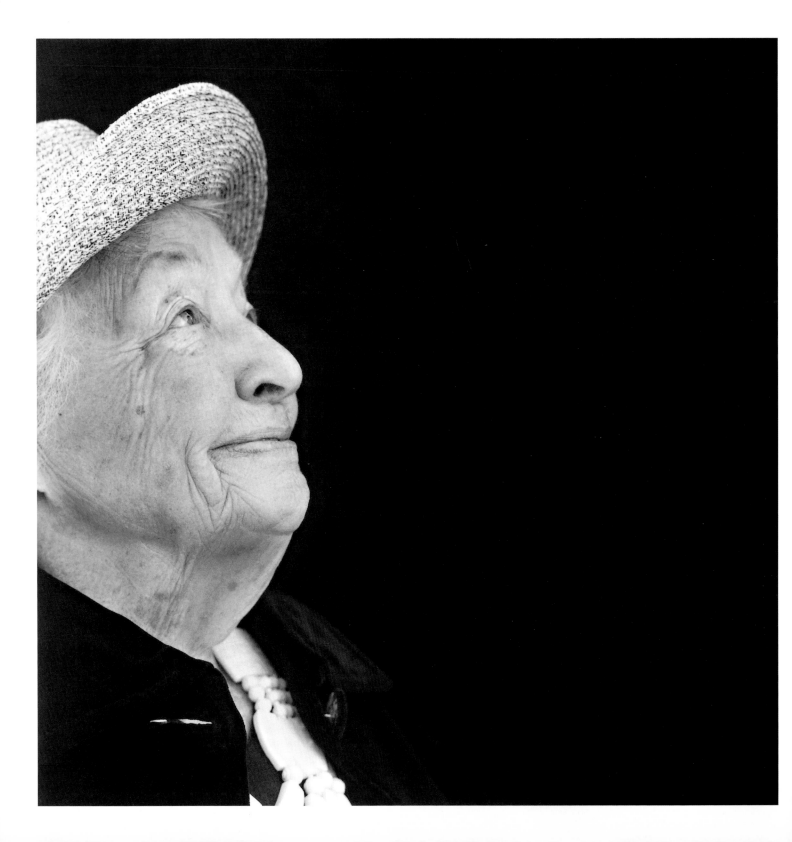

The Quilt

For Kate

I shall quilt you a story from plain calico words, fitting, homespun.

Little pieces of our past, wisely patched together into Twirling Stars

from spinster's hopes, mother's cares, grandmother's worn hands.

Minuscule stitches, each one a lesson, each a memory hard won.

Come and sit by my side. Sing the old, sweet songs, if you dare.

Log Cabin and too soon the long childhood's over. Flowering Tree.

Double Wedding Ring. Tell me dear, was he kind, that handsome,

passionate one? Did you weave widowed scraps, sisters cast-offs,

precious baby things into glad borders of red, white and blue?

Those small, cherished heads you held in your hands, tears again

falling, are they nearby — or did they hasten to bid you adieu?

From this valley, too soon, we shall all be going. Won't you share

your bright eyes and sweet smile? Won't you embroider the sunshine

keeping our love's glowing threads tight until the last knot be tied?

Adela Roatcap

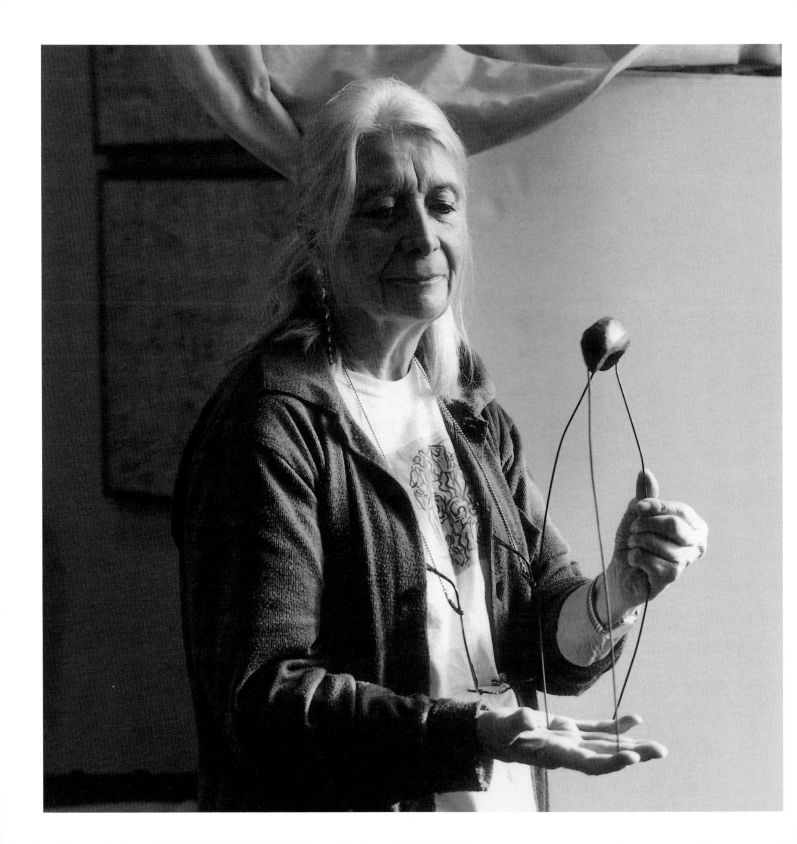

Introduction

This collection of portraits and verbal snapshots is a celebration of the "female spirit" and a tribute to the diversity and strength of women. It salutes the ordinary yet remarkable lives of fifty-seven older women. As individuals, they couldn't be more different. Some stand out because of their actions in life; others, because of their attitude toward it. Some stood behind a man; others, in front of one. Some remained single by choice; others, by chance. Some gave birth to children; others, to ideas. Some worry about money; others seldom think about it. Some have overcome serious health problems; a few have never been sick a day in their lives. Some are quiet and shy; others, feisty, gutsy, and always the life of the party. Some stayed happily married for sixty years; others married six times.

The women in this book are either "wonderful characters" or they possess tremendous character. Living in a culture that idolizes youth and celebrity, these women offer a very human, sometimes humorous, and always thought-provoking reflection on life. Their portraits, I hope, capture both their spirit and their humanity. And their current lifestyles demonstrate that getting older does not necessarily mean "living old."

It was during a "girls' night out" five years ago when the idea for this book developed. What to expect as we grow older was the theme of the evening. There were six of us, all in our late forties and early fifties, and we were speculating on how some women not only survive growing older, but also seem to flourish in spite of it. We debated how each of us would deal with the inevitable descent into our next decade. If we were lucky, we joked, we could look forward to deteriorating minds and bodies; our grown children coming home (and I don't mean to visit); retiring husbands who want to run the house; or living alone again, or for the first time. It was no surprise to us that once again, the real issue of the evening was our endless pursuit of sanity and serenity. In different ways we were all questioning where we were going in life and felt unsure about how we would define happiness in the years to come.

A few months later, my project, which evolved into a five-year journey crisscrossing America, was underway. I conducted the personal interviews and photo sessions as I traveled the main streets and back roads of our country from New York to New Mexico . . . Connecticut to Florida . . . Arizona to Ohio . . . California to the Carolinas. My vision was that this project would be both geographically and psychologically diverse. I wanted women from many walks of life. I started close to home, asking friends and neighbors for suggestions of interesting older women. Ultimately, my search took me to the doors of social service agencies, local newspapers, and community centers. Sometimes I would see someone on the street who captivated me, and the next thing I knew, we were talking. Along the way, I asked taxi drivers and waitresses alike if they knew someone very special who would be a great addition. People were always happy to help; they were intrigued by the project. I met with little rejection, doors opened easily, and I was greeted with humor and lots of goodwill. One woman said, "I'd be happy to be in your book, but do you really think anyone will buy it? I haven't noticed that old ladies are very popular these days, but then again, with all the crazy things happening in the world today, who knows, maybe taking advice from older women will be the next fad."

As my travels continued, I kept asking myself, "what am I learning from this experience?" It was obvious that these women grew up in a world that no longer exists. They were born before World War II, the onset of television, and the women's liberation movement. They had witnessed unimaginable change, both good and bad. They adapted, changed with society, and their view of the world evolved along with their definition of fulfillment. I came to believe that many of them grew into themselves and, perhaps for the first time, became truly comfortable in their own skin.

It was interesting to find many women in their seventies and eighties working out, dating, and continuing to move forward without a road map in their hands. It became so very clear that there are many paths to happiness and fulfillment. And that some paths have dead ends that force us to go backwards—to pick up that old map, think things through once again, and move on in a new direction. I learned that it is never too late to grow. People who welcome new people, experiences, and ideas into their lives remain vital.

During the course of the interviews, I continued to hear that oftentimes the lessons of an entire lifetime are only fully understood and appreciated in the last chapters. I found it comforting that women are kinder to themselves and each other as years pass. And it was heartening for me to see that as women age, time seems to be feared less and valued more. Many of the women felt that in their younger years, they were looking outward for answers, but today they look inward. As a photographer, I confirmed that behind a stern countenance, warmth and laughter could lie unseen. And behind a smile could be many tears. I also noted that while being a little "salty" and having a great sense of humor may not scientifically add years to a woman's life, their absence could take years away.

Women with spirit, such as those in this book, live on every block in every neighborhood. It is my belief that they are the core of our society and the heart of our country. As their lives continue to unfold, some are content with fond memories of the past. For others, it's the simple joys that matter—the music they love, the books they read, the classes they take or teach, the businesses they run, and most important of all, the families and friends they treasure. And then too, for a few, it's a belief in dreams yet to be fulfilled.

It has been the joy of my life to meet and get to know each of these women. It was a challenge to capture the richness of their being through a portrait and a few of their own words. I offer only a glimpse and leave much to your imagination. Through their lives and reflections, they are mentors to us all.

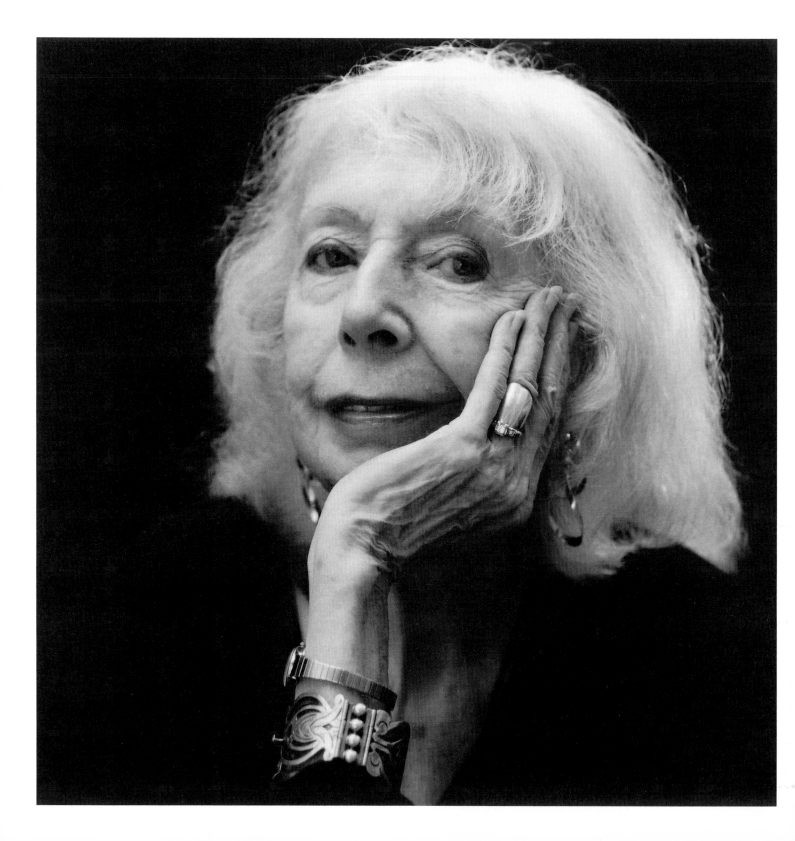

DIVAS, DAMES & DOLLS

A CELEBRATION OF THE FEMALE SPIRIT

Eunice Beach

"My childhood had a great bearing on who I have become.
My two older sisters teased me from morning to night, calling me stupid and ugly. I was very skinny
and wore thick glasses. I believed them. As the youngest in a large family, my parents were too tired to
notice what I was going through. Without knowing it they taught me to try harder than anyone else."

"One night, I was hiding behind the curtains as I often did. My father, who was unusually tense,
said to my mother: 'Priscilla, today I sold the house and bought land.' For what seemed like an eternity,
she said nothing and then quietly spoke: 'Ellsworth, as long as you are married to me, you will never do
anything else without my consent.' As far as I know he never did. That night, I learned the power of silence."

"A teacher changed my life. No one saw my potential except her. She encouraged me
with kind words, physically held me in her arms when I was emotionally starving,
and gave me the gift to believe I was worthwhile enough to become the best possible me."

"I married for the first time because of immaturity; the second time was for security.
Until I was eighty, I didn't have the best luck with men. After having a hip replaced and a breast removed,
I discovered real love for the first time. I probably shouldn't say this because it's nobody's damned business.
But, I'm not kidding when I tell you that the best sex of my life started at eighty."

"When people talk about the good old days, don't believe them.
There wasn't any such thing—there was always trouble.
My advice to the next generation is don't go back on the same spacecraft you came over on."

EUNICE HAS A DEEP, BAWDY LAUGH AND A PAIR OF LEGS THAT ANY WOMAN IN HER TWENTIES WOULD ENVY. BORN IN WESTERN MAINE,
SHE WAS THE YOUNGEST OF THIRTEEN CHILDREN. TODAY, SHE IS THE ONLY ONE ALIVE. SHE MARRIED TWICE AND HAS ONE SON AND ONE GRANDSON.
THROUGHOUT HER LIFE SHE HAS BEEN A CLOTHING DESIGNER, INTERIOR DESIGNER, AND AN ARCHITECT. A GRADUATE OF THE
NEW YORK SCHOOL FOR INTERIOR DESIGN, SHE HAS LIVED IN BOSTON, PARIS, AND PITTSBURGH, WHERE SHE OPENED
THE PITTSBURGH INTERIOR DESIGN SCHOOL WHEN SHE WAS IN HER SEVENTIES. UP UNTIL HER LATE EIGHTIES, SHE WAS DESIGNING AND
MAKING HER OWN CLOTHES AND CONTINUED TO GIVE ADVICE TO AND BOOST THE MORALE OF HER MANY GRATEFUL STUDENTS. TODAY SHE SAYS SHE IS
WORKING ON HER MOST IMPORTANT INTERIOR DESIGN PROJECT . . . HER SOUL. SHE IS NINETY-TWO YEARS OLD AND LIVES IN PITTSBURGH.

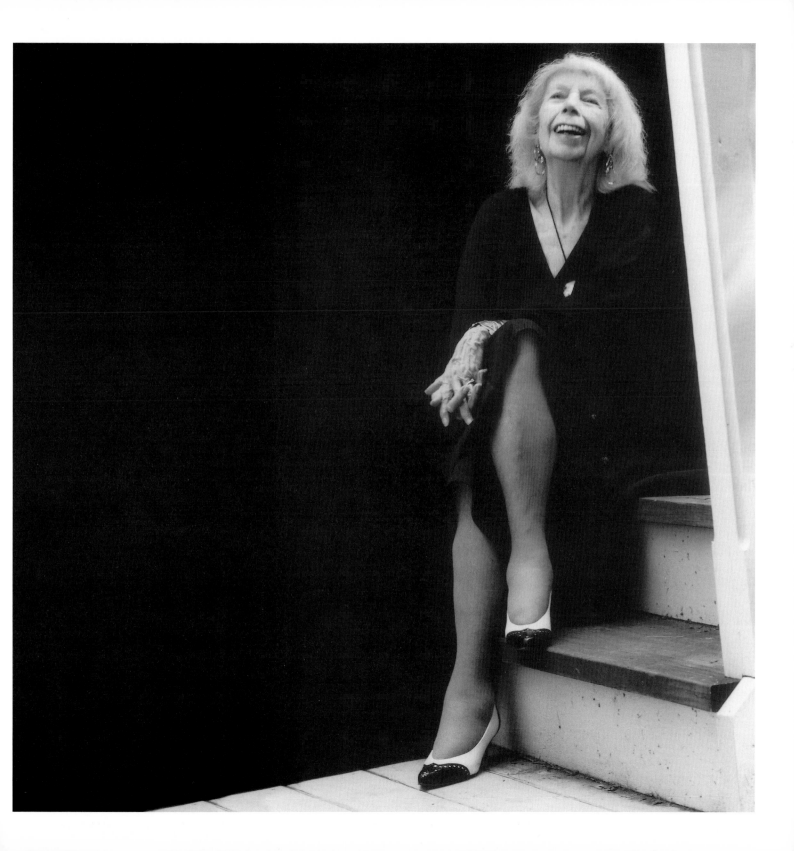

Dolly Donnelly

"I found out the difference between the sexes
when I tried riding my brother's bicycle."

"My first husband was Irish with the face of an angel,
but he picked up the bottle instead of a harp."

"I used to love antiques until I started becoming one."

"If you have talent, don't take credit for anything.
Give the credit to God, who gave you the gift."

"When trouble knocks on your door, pick yourself up,
brush yourself off, and hope you don't land in a mud puddle."

"I'd rather have a new hat than a good meal."

"The hardest part of getting older is that you know what can happen."

WHEN HER PARENTS NAMED HER DOLLY, THEY KNEW WHAT THEY WERE DOING. KNOWN AS "THE HAT LADY," SHE IS NEVER SEEN WITH
WITHOUT ONE. A MILLINER FOR MANY YEARS, SHE ENJOYS LIFE TO THE FULLEST. THIS MOTHER OF SIX AND GRANDMOTHER OF THIRTEEN IS ALSO
A PAINTER WHO SINGS IN THE CHURCH CHOIR. SHE WAS MARRIED TWICE, BOTH TIMES FOR TWENTY-TWO YEARS. HER SECOND HUSBAND DIED IN HER ARMS
AFTER FALLING DOWN A FLIGHT OF STAIRS ON THEIR WEDDING ANNIVERSARY. LIKING TO KEEP BUSY AND WANTING SOME SPARE CHANGE IN HER POCKET,
DOLLY JUST STARTED HER OWN HOUSEKEEPING BUSINESS. SHE IS EIGHTY-FOUR YEARS OLD AND LIVES IN JAMESTOWN, CALIFORNIA.

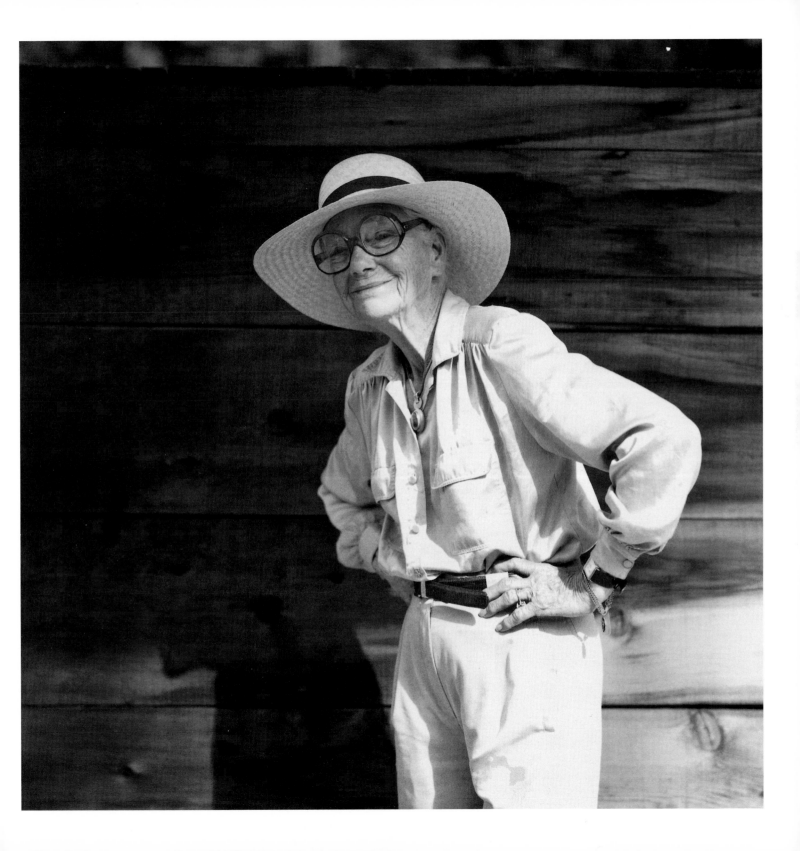

Esther Burton

"*Impossible* is the word for me as a child.
I got drunk at seven years old. I was so sick that I never went near alcohol again."

"Some people see me as complicated and maybe even eccentric.
I think those words are merely an excuse for their laziness and lack of curiosity.
I stick to the Bohemians—a dying breed in this world of gentrification—
for pleasure and growth."

"The older you get, the less opinions you should have on anything."

"In this country, people place too much value on youth, looking young, acting young.
Old people demand little because they have transcended their
urgent desires beyond the need to compete."

"I don't want to be admired because I don't act old. I am old.
I also happen to have many young friends, who I keep telling, 'Will you let me be old, please?'"

"The best thing about our society is the middle class way of life."

"People should remember that they see the world only through their own eyes."

KNOWN BY HER DEEP VOICE AND DEEPER CONVICTIONS ABOUT LIFE, ESTHER HAS LIVED A LIFE OF EXTREMES.
SHE SMOKES LIKE A CHIMNEY AND HAS NO INTENTION OF PUTTING OUT THE FIRE. AS A CORPORATE WIFE, SHE LIVED IN AFRICA,
EGYPT, PARIS, AND SPAIN. MARRIED TWICE, SHE HAS BEEN A CHEF, MAID, HOTEL OWNER, MUSICIAN, PAINTER, AND GALLERY OWNER.
WITHOUT EVER EARNING A DEGREE, ESTHER GOT A WORLD-CLASS EDUCATION. SHE HAS LIVED ALONE FOR FORTY YEARS AND
RECENTLY HAD HER FIRST ART SHOW, IN HER HOMETOWN OF JEROME, ARIZONA. SHE IS SEVENTY-THREE YEARS OLD.

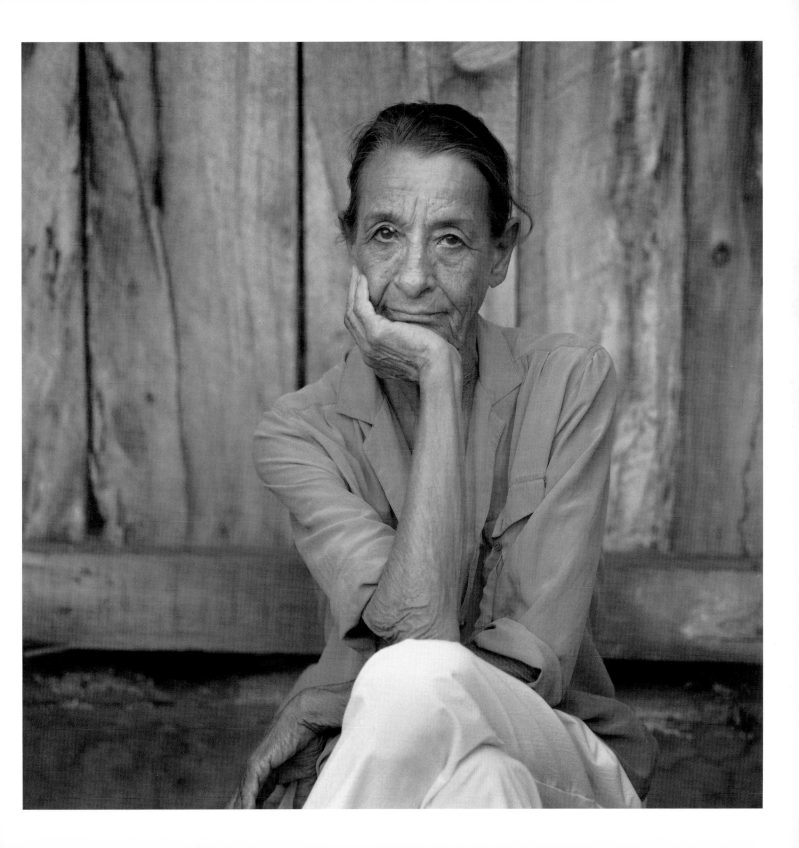

Joan Singer

"When I was young I believed in rules. I don't anymore.
I was a busy little girl, far too busy to look at myself.
My mother was a social climber who would often comment that people looked right.
From as far back as I can remember, I rejected most of her core values."

"I grew up not knowing my roots.
I didn't learn that my father was Jewish until I was in my teens.
I was shocked because I thought I was a WASP, and I didn't know anyone who was
different from me. I stopped, opened up my mind, and changed forever."

"Creative is a word that I would never use to describe myself.
However, I am a great admirer of unexpected talent, and I make a wonderful audience."

"On my deathbed, I will remember the one time I really fought for something I believed in.
It was an environmental issue. I'm proud that just once I cared enough to take a stand."

"I never give advice. Nobody listens anyway.
They look at how you live your life and learn from that."

NEAT, ORGANIZED, AND LOGICAL BY NATURE, JOAN FINDS HER CREATIVITY IN THE GARDEN. IT IS THE ONE PLACE SHE DOESN'T LET ANYONE TELL HER
WHAT TO DO. BORN IN CLEVELAND, OHIO, SHE HAS BEEN MARRIED FOR FIFTY YEARS AND IS THE MOTHER OF THREE BOYS, TWO SPECIALLY CHALLENGED.
JOAN WENT BACK TO WORK AFTER HER CHILDREN WERE GROWN, AND BECAME A COMPUTER SCIENTIST, LONG BEFORE MANY OF US KNEW WHAT A COMPUTER
WAS. TODAY SHE RUNS HER OWN COMPUTER TRAINING BUSINESS AND IS ACTIVE WITH THE LOCAL CONSERVATION COMMITTEE,
THE LEAGUE OF WOMEN VOTERS, AND WELLESLEY COLLEGE ALUMNAE. AS SHE HAS IN THE PAST, IN BETWEEN LAUGHS SHE INTENDS TO CONTINUE
TACKLING THE COMPLEXITIES OF LIFE AS THEY APPEAR. JOAN IS SEVENTY-FOUR YEARS OLD AND LIVES IN WESTPORT, CONNECTICUT.

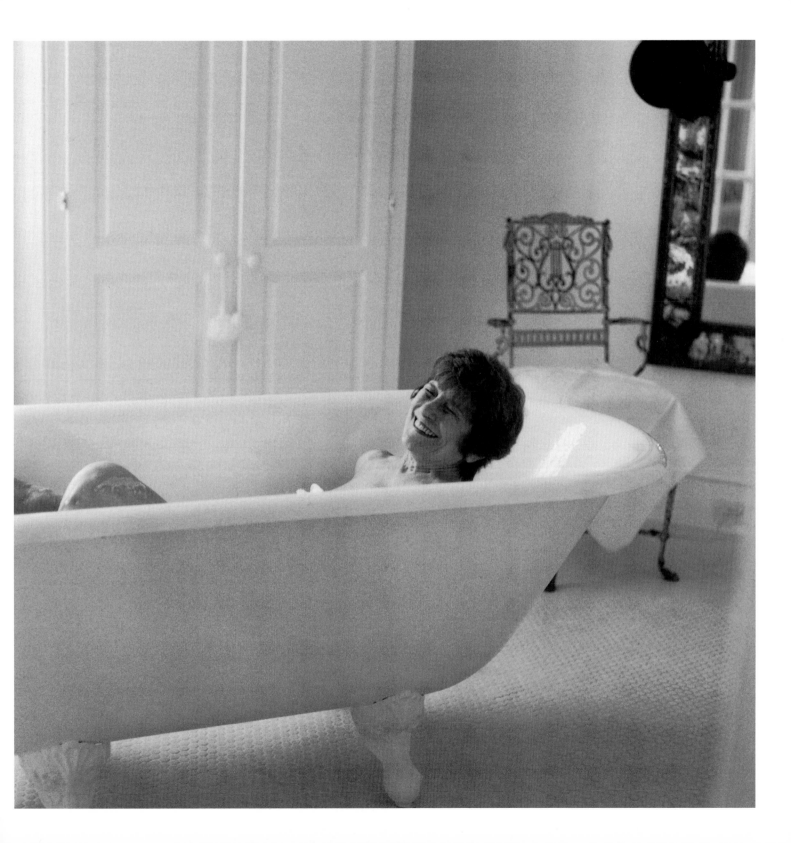

Helen Nelson

"As a youngster I was shy,
and that was often unfortunately misunderstood as being aloof."

"The most important thing a person can do is to get to know themselves.
Sit down and talk to yourself, and then pay attention to what you have to say."

"Getting married is wonderful if it adds to who you are.
Having two separate identities makes a good marriage."

"Women are problem fixers.
Whenever there is a real mess, a woman is brought in.
Years ago, a woman with an education didn't get a chance to use it.
I do think society is heading in a wonderful direction.
Men are becoming more involved with their children, and women have choices."

"Beating an addiction is a wonderful thing.
I stopped smoking after twenty years. And I'm still proud of it.
Doing anything hard and succeeding is a gift to your self-esteem."

"When people look at an old woman, they don't think of her as having had a passionate,
forbidden love affair that can sustain her all the nights of her life."

"At the end of the day, I either read or listen to rap music,
which I believe is the poetry of the day."

QUIET, THOUGHTFUL, AND MODEST ABOUT HER ACCOMPLISHMENTS, HELEN WAS A CONSUMER ADVOCATE FOR BOTH
THE KENNEDY AND JOHNSON ADMINISTRATIONS. WITH A MASTER'S DEGREE IN ECONOMICS, SHE MARRIED AND DIVORCED EARLY, LEAVING
WHAT SHE CALLS A MEDIOCRE MARRIAGE FOR THE LOVE OF HER LIFE AND HUSBAND OF THIRTY YEARS. UNABLE TO HAVE CHILDREN DUE TO AN
EARLY HYSTERECTOMY, SHE CREATED HER LIFE IN A DIFFERENT WAY THAN SHE HAD FORESEEN. HELEN MADE AN AWARD-WINNING
DOCUMENTARY FILM ABOUT CONSUMER RIGHTS IN HER EIGHTIES. NOW WIDOWED, SHE LIVES IN HER OWN HOME IN SAN FRANCISCO
AND ENJOYS ENTERTAINING, GOOD WINE, AND LIVELY DINNER CONVERSATION. SHE IS EIGHTY-NINE YEARS OLD.

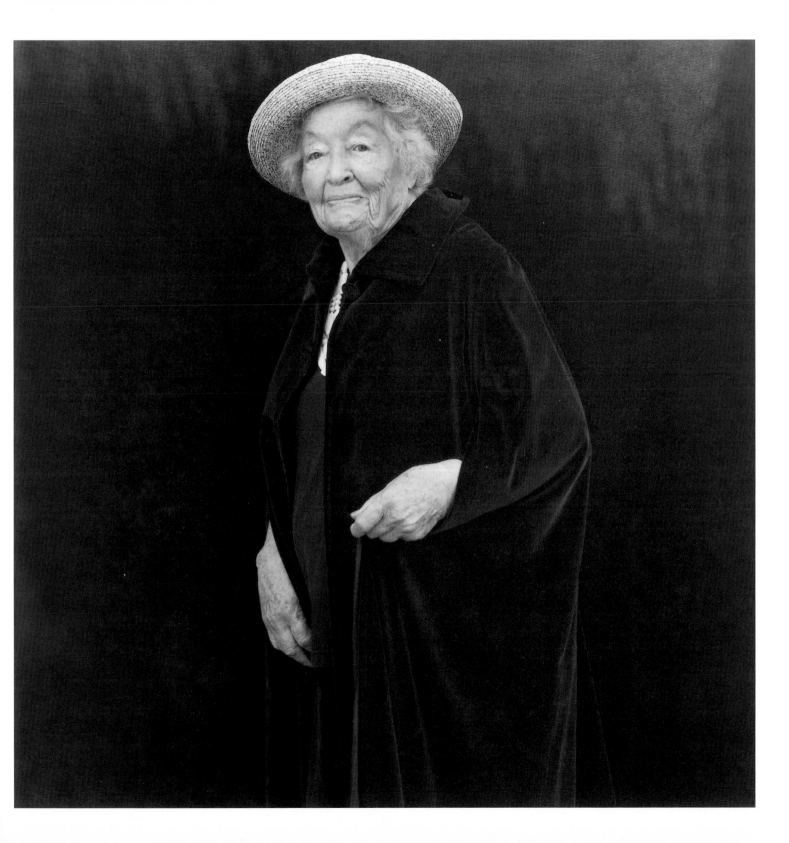

Sarah Hamlin

"As a young girl, I learned to always have more than one expectation for every dream."

"Most of my life I have not been aware of being happy.
Most days are like the ones before. But a few times, I have been aware that
I was living in a never-to-be-forgotten, perfect moment."

"It's hard for women after their husbands pass away.
When you are no longer a couple, you're left out a lot; people drop you,
and often, you not only lose your husband, you lose your social standing."

"I have been a widow for twenty-five years, and I'll be honest, I let my husband make
decisions for me. If he came back now, I don't think he would want to stay.
Because no one makes decisions for me anymore."

"I am black and white but rarely blue. I was raised in a segregated society and feel
blacker than white, but my roots are both. I believe that if people could see their family tree,
there would be a lot less prejudice and an understanding that all of our roots are intertwined and that,
my goodness, we should all be accountable to one another."

"People think they know where their genes have been, but nobody knows where they might be going."

"Milking the cow and hanging the clothes on the line
was easier than the lives of many working women today."

A ROSE IN FULL BLOOM, SARAH WAS A FLORIST FOR FORTY YEARS BEFORE BECOMING A GENEALOGIST AND HISTORIAN. SHE IS THE WELL-DESERVING WINNER OF THE ECHO AWARD (EVERYONE CAN HELP OUT) AND IS DOCENT CHAIRWOMAN OF HISTORICAL HOMES. IN THE 1960S, SARAH STARTED THE FIRST RACIAL DIALOGUE GROUP AT THE YWCA. TODAY SHE WORKS ON RESTORING ABANDONED GRAVEYARDS AND HELPS MANY PEOPLE DISCOVER THEIR ROOTS. THIS MOTHER OF THREE AND GRANDMOTHER OF EIGHT LIVES IN FORSYTH COUNTY, NORTH CAROLINA. SARAH IS EIGHTY YEARS OLD.

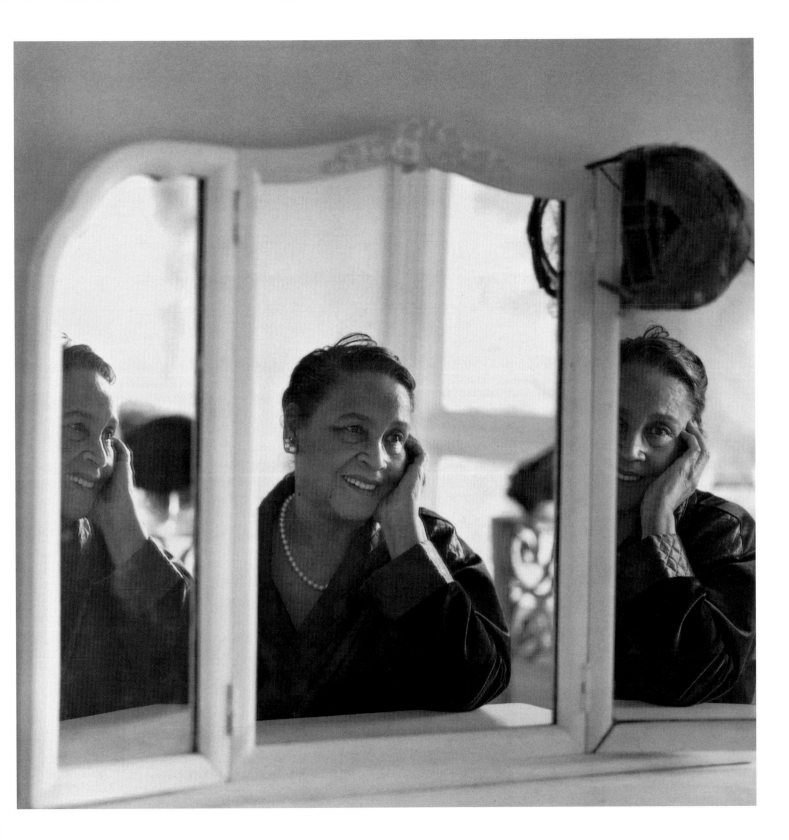

Patsy Chador

"I was a willful little thing.
I used to jump on trains never knowing or caring where they would take me."

"Don't ever say a book can't change your life.
I was in my twenties when I read *Exodus* and took off for Israel,
where I met my husband while I was living in a kibbutz."

"Several years ago I was having lunch with a friend. When I looked into her eyes
I heard myself talking. I didn't have a nice thing to say about anyone or anything. I had turned
myself into a witch. I didn't want to be that person. I heard myself, and I changed."

"Life is a dance with dips, twirls, twists, and different beats.
Sometimes your partner steps on your toes, sometimes you trip over yourself . . .
it's all about continuing the dance and enjoying the next song."

"First there was a pill for women so they wouldn't get pregnant. Now there is
a pill for men so they can still get women pregnant. A woman gets to menopause and
is encouraged to take some more pills so she can remain sexy and nice.
I can't wait to see the day that my husband wants sex and I can show him the medicine cabinet."

"I don't ever think about the hereafter.
The way I see it, if you live every day as the best person you can be,
whatever comes after will take care of itself."

THE FACT SHE LIVED IN A KIBBUTZ WOULDN'T BE UNUSUAL EXCEPT FOR THE FACT THAT PATSY IS AS IRISH AS GUINNESS. A CALIFORNIA GIRL WHO
WOULDN'T KNOW HOW TO NOT HAVE A GOOD TIME, SHE HAS BEEN MARRIED FORTY YEARS AND IS THE MOTHER OF THREE AND GRANDMOTHER OF THREE.
PATSY WORKS MANY HOURS EACH WEEK READING TO PEOPLE IN NURSING HOMES. SHE TEACHES MUSIC APPRECIATION AT MARIN COMMUNITY COLLEGE
AND SELLS HER OWN WHIMSICAL FOLK ART AT LOCAL GALLERIES. PATSY IS SIXTY-ONE YEARS OLD AND LIVES IN MILL VALLEY, CALIFORNIA.

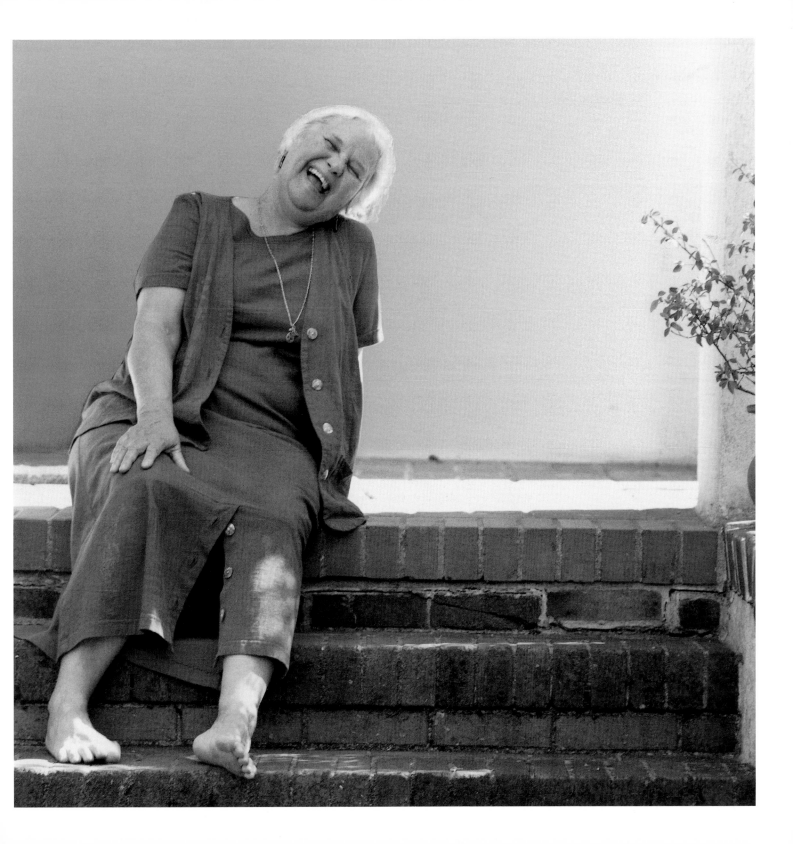

Queenie Vinson

"I was a devil-child with a big mouth.
Whatever came up came out. My husband says I haven't changed a bit."

"My father used to shake his head and say, 'Queenie, you are a people-lover,
and people-lovers get hurt.' He was right about that, but he was wrong about how it affected my life.
Sure, I've been hurt many times; I am sensitive, but being hurt hasn't hurt me. It made me strong."

"Children are my life, and I always hoped I would have a houseful. But God had other
plans for me. I wasn't able to have my own, but I've kept my spirit young by working with them.
We teach each other, and most of the time, I'm not sure who is learning the most."

"Every day that I do something good or something nice happens to me,
I look back and count that day as a happy ending.
At the end of my life, I'll have many more happy endings than sad ones."

"When I was younger, I would be afraid and sad often, for no apparent reason.
I started praying and before long, I stopped worrying completely.
God reached down, grabbed my problems, and I've walked light ever since."

QUEENIE'S HEART IS ALL OVER HER FACE. HER SWEET, CHILDLIKE VOICE GIVES NO INDICATION OF THE WILL OF STEEL THAT SUPPORTS HER BODY.
BOTH KNEES HAVE BEEN REPLACED DUE TO SEVERE ARTHRITIS, YET NO MATTER WHAT THE WEATHER OR DISCOMFORT, SHE WALKS A MILE TO AND FROM
THE CHILDCARE COMMUNITY CENTER WHERE SHE VOLUNTEERS EVERY DAY. BORN IN SOUTH CAROLINA, SHE NOW LIVES IN BRIDGEPORT, CONNECTICUT.
QUEENIE IS PAST PRESIDENT OF THE NATIONAL COUNCIL OF NEGRO WOMEN, SUNSHINE SECRETARY FOR THE JEWISH COMMUNITY CENTER,
AND MEMBER OF THE FOSTER GRANDPARENTS PROGRAM. MARRIED FOR FIFTY YEARS, SHE HAS TWO ADOPTED SONS AND FIVE GRANDCHILDREN.
BELIEVING THAT IF SHE EVER SITS DOWN, SHE WILL NEVER GET UP AGAIN, SHE KEEPS MOVING. QUEENIE IS SEVENTY-EIGHT YEARS OLD.

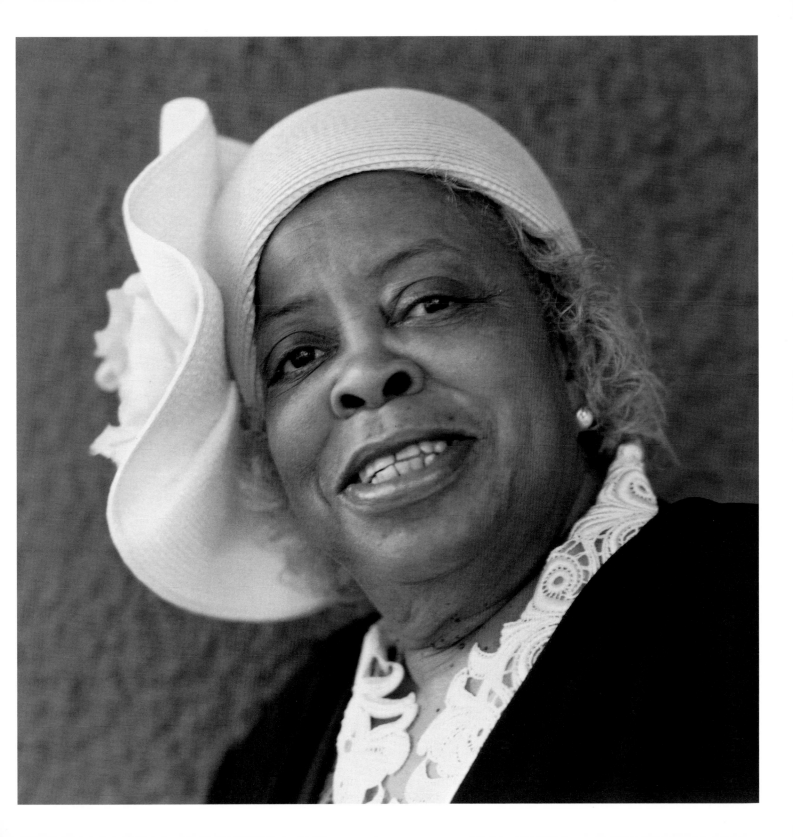

Elsie Neal

"When I was a small child, I was orphaned.
I was so happy when I was adopted.
I didn't know that I was not to be their child, but their slave."

"I used to sleep with a picture of a beautiful blue dress I found in a
catalog under my pillow. I would fall to sleep dreaming one day that dress
would be mine. I never did get that dress but I doubt that it would
have brought me as much happiness as that picture did."

"By the time I was fifteen, I didn't want to live anymore;
I tried running away, but I was told they would put me in jail, so I tried to kill myself.
Things were a little easier after that. I wanted to go to high school very badly,
but they wouldn't let me. When I fell in love, I got engaged secretly. He went to war
and I stopped hearing from him. I was heartbroken. Years later,
I found out that all my letters and all of his had been burned by my foster parents."

"I wish I had more wisdom. I sure can tell you how to bake an apple pie.
And you can't miss with my chicken and dumplings. That's all I really know.
Oh, and I know that if you throw something away, you will need it tomorrow.
That I know for sure."

"What I like about my age is that I'm alive and healthy,
yet I have no future to worry about. It's wonderful."

It was Elsie's dream to become a writer, and her dream came true when she wrote her life story and self-published it, at the age of eighty-five. Understanding the value of a dollar, she has always been a hard worker, sewing her own dresses, coats and hats. Elsie has worked in a shirt factory, funeral home, and in her spare time volunteered at the blind girls' home in Nashville. Divorced after a thirty-two year marriage, she did find her old lover, but decided that you can't go backward in time. This mother of four has lived in Texas and Tennessee. Elsie has thirteen grandchildren and thirteen great-grandchildren. Every weekend she can be found at the local flea market with her faithful companion, her cat Matilda. She is ninety-two years old and lives in Slayden, Tennessee.

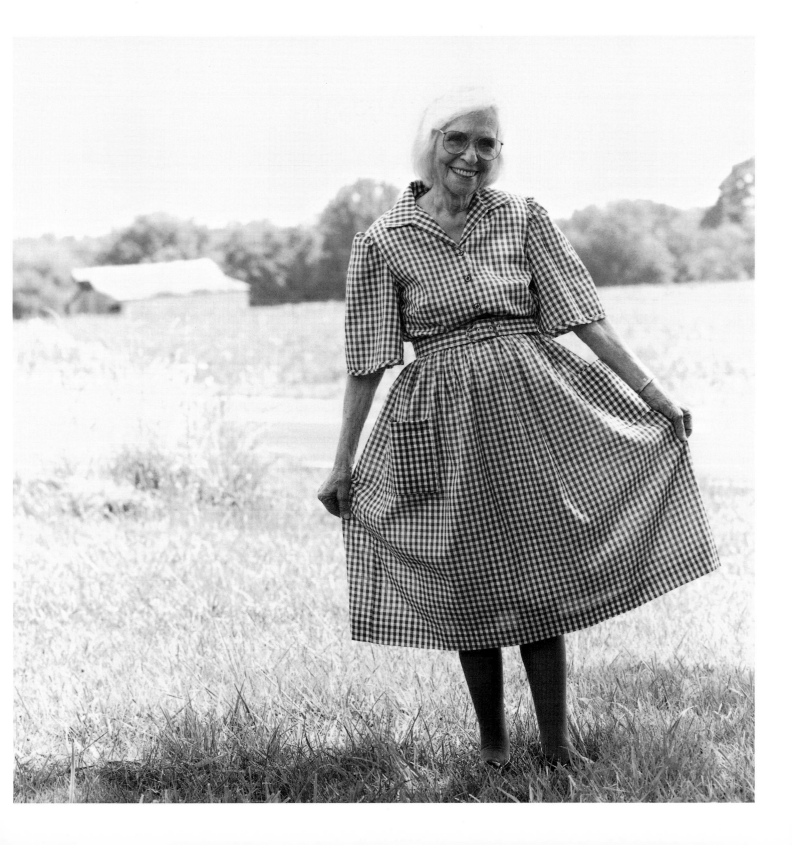

Liz Metsos

"As a girl, I was meek and obedient.
I remember being in school, probably around fourth grade, and a beautiful, blond-haired,
blued-eyed little girl sat behind me. All day long she would tease and torment me.
One day I took my pen, which back then was filled with ink, turned around and let her have it.
In that moment I learned how to stand up for myself.
The teacher who knew what I was going through did not punish me.
When I look back, I realize that little girl taught me compassion. I hope I taught her something."

"At thirty I was diagnosed with cervical cancer.
Back then it was a death sentence. The word itself was whispered doom.
My immediate fear was not for myself but for my parents.
I couldn't bear the pain they were in. I managed to beat the odds."

"I am a businesswoman, and as one, I believe there are no hard decisions.
Get the facts . . . make up your mind from the information you have, and see what happens."

"From the time I can remember, I have loved to cook.
Just being near the kitchen makes my heart race.
My mother used to say that I came out of the womb with spatula in hand."

"I do not make time for things I don't like. My menopause lasted about five minutes."

"When I turned sixty, I decided to do 'The Year of the Liz.'
From butcher to baker to candlestick maker, I went. Changed bad eating habits,
started an exercise program, got a new look, stopped cursing and started praying."

A PIED PIPER OF WOMEN: THERE IS SOMETHING ABOUT LIZ THAT DRAWS PEOPLE IN. SHE THROWS OUT AN IDEA AND EVERYONE FOLLOWS.
KNOWN FOR HER ECLECTIC DINNER PARTIES, GOURMET COOKING, AND OFF-BEAT SENSE OF HUMOR, LIZ, WHO COMES FROM A
LARGE GREEK ORTHODOX FAMILY, HAS AS MANY MEN FRIENDS AS SHE DOES WOMEN. TO HER NIECES AND NEPHEWS, SHE IS AUNTIE MAME COME
TO LIFE—SO ZANY AND OUTRAGEOUS THEY END UP TELLING ON HER. SHE IS THE PRESIDENT OF A SAFETY-PRODUCT COMPANY AND LIVES WHERE SHE WAS
BORN, IN FAIRFIELD COUNTY, CONNECTICUT. SHE IS SIXTY-SEVEN YEARS OLD.

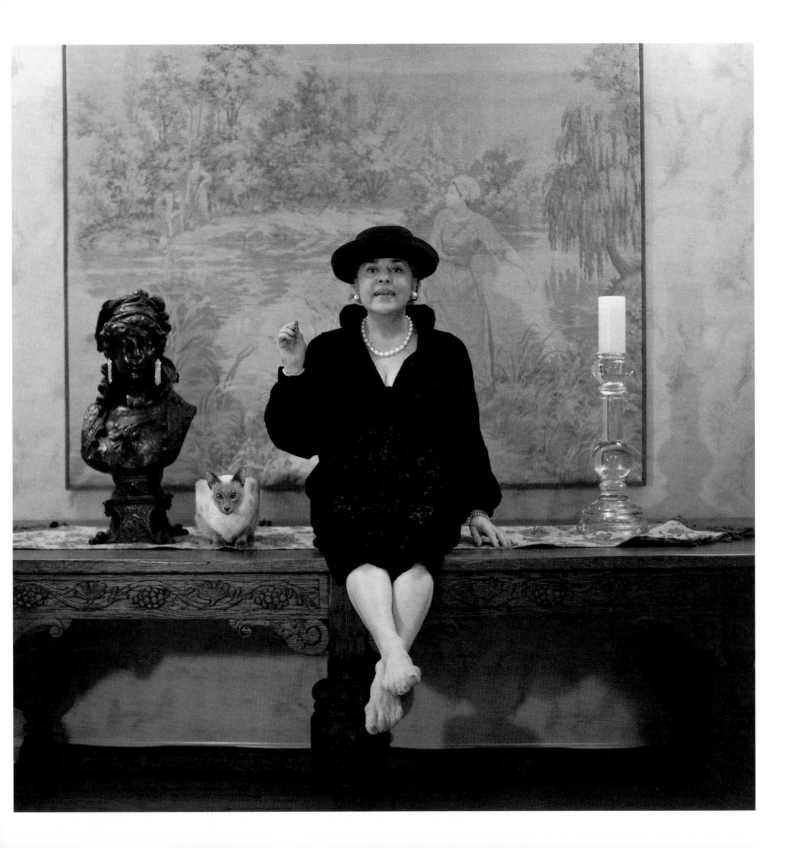

Copey Hanes

"I knew I was loved . . .
carefree, secure, and happy is how I would describe my childhood.
My father was a minister; my mother a housewife.
We lived on a block with sidewalks. All day long we ran up and down the block
doing things little girls did back then, playing house with baby dolls, roller-skating."

"The secret of having a wonderful marriage is simply to love the other person more than yourself.
Being a widow is hard, and it doesn't get easier.
I miss him more every day. It's like living with a physical part of yourself missing."

"Today's culture is pathetic.
Years ago people didn't allow themselves to be exposed to vulgar things.
There was a self-pride and richness in values. Today, people have lost their ability to be shocked."

"We are living in over-communication . . . the modesty, mystery,
and magic of discovery seem to be social dinosaurs.
Young people today believe they're being moral if they wait until the third date to jump under the sheets."

"As a mother, I believe in love and discipline.
I also believe that if your child doesn't get many disappointments, create them . . . they build character."

"Many of my friends are women; however, none are man-crazy.
I have observed that the more man-crazy a woman is, the more trouble she has with men.
Vain women, or older women who try to appear young by having face-lifts,
plastering their faces with makeup, and wearing too-short skirts, are ridiculous.
They actually believe they look young. I think they look like jackasses."

COPEY HAS NO PROBLEM WITH YOUR BUYING THE UNDERWEAR HER FAMILY IS FAMOUS FOR, BUT SHE WOULD PREFER YOU NOT TAKE THEM OFF TOO QUICKLY. A HANDSOME WOMAN WHO IS EVERY INCH THE LADY, SHE IS A FORMER TEACHER WHO WAS MARRIED TO HER BEST FRIEND FOR FIFTY-FOUR YEARS. A SUPPORTER OF THE ARTS IN EVERY WAY, COPEY IS ONE OF THOSE PEOPLE WHO, THROUGH NUMEROUS CHARITABLE WORKS, HAS MADE AN ENORMOUS CONTRIBUTION TO HER COMMUNITY. SHE HAS THREE CHILDREN AND SIX GRANDCHILDREN. BORN IN CALIFORNIA, SHE NOW LIVES IN WINSTON-SALEM, NORTH CAROLINA AND IS EIGHTY-FIVE YEARS OLD.

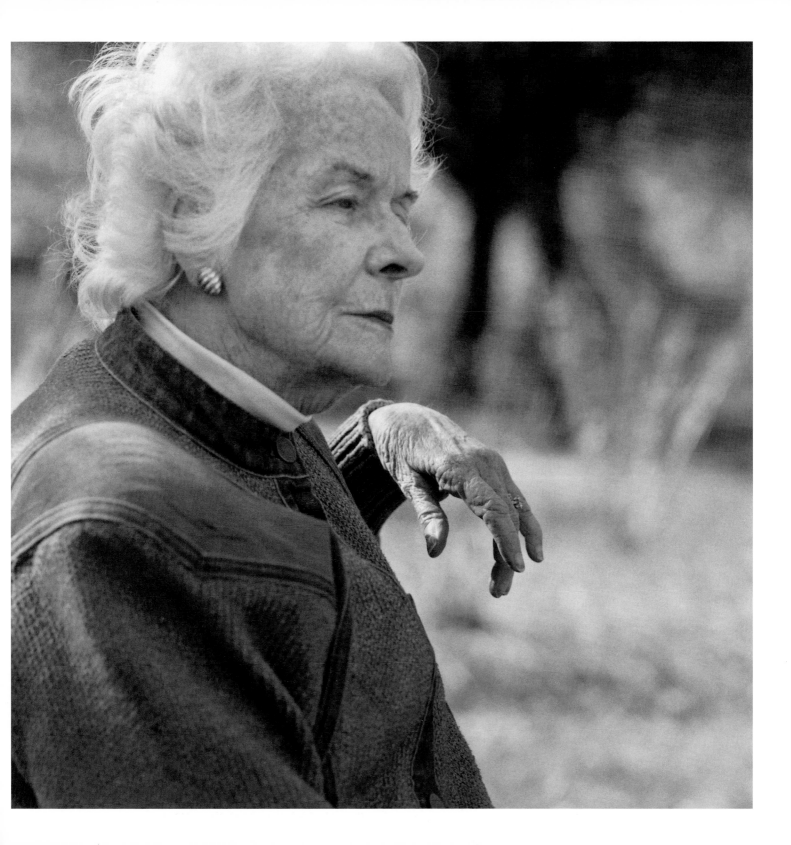

Ann Brignolo

"My parents were strict and didn't take any nonsense.
It wouldn't have entered my mind to disobey them.
They taught me to walk a straight path,
not to break promises, and don't do anything lightly."

"My life has been like a wonderful old black-and-white movie
that I wouldn't mind seeing over and over again.
The picnics, the state fairs, the dancing, the laughing, and wonderful conversation.
We lived life. We didn't watch it."

"I always wanted to be in show business and my dream came true.
After I married the owner of the nightclub where I worked,
I went from showgirl to cashier. I was so in love I didn't care and that never changed.
I was far too busy learning and working to give much thought to the feminist movement."

"The smartest thing I did in my life was to play with my children."

"People trust me and call me the neighborhood matriarch.
I'm proud of the fact that I get things done."

THERE IS A TWINKLE IN HER EYE AS IF SHE HAS AN AMUSING SECRET SHE'S NOT GOING TO TELL. EACH MORNING BEFORE BREAKFAST, ANN CROSSES THE STREET TO THE NEIGHBORHOOD PARK (WHICH SHE IS COMMISSIONER OF) IN BRIDGEPORT, CONNECTICUT, AND PICKS UP THE TRASH FROM THE EVENING BEFORE. BORN IN NEW YORK TO AN ITALIAN FATHER AND ENGLISH MOTHER, SHE WENT ON TO BECOME A GRADUATE OF THE RUSSIAN SCHOOL OF BALLET. IN HER TWENTIES, SHE TRAVELED ALL OVER THE WORLD ON CRUISE SHIPS, WORKING AS A DANCER. IN HER SIXTIES, ANN BECAME A MULTI-AWARD-WINNING PHOTOGRAPHER, AND NOW, ALONG WITH RUNNING HER OWN BUSINESS, SHE GIVES PHOTOGRAPHIC SCHOLARSHIPS TO UNDERPRIVILEGED CHILDREN AND IS PRESIDENT OF THE COMMITTEE TO REHABILITATE INNER-CITY HOUSING. ANN IS A WIDOW WHO WAS MARRIED FOR SIXTY YEARS. SHE HAS THREE CHILDREN, SIX GRANDCHILDREN, AND IS EIGHTY-TWO YEARS OLD.

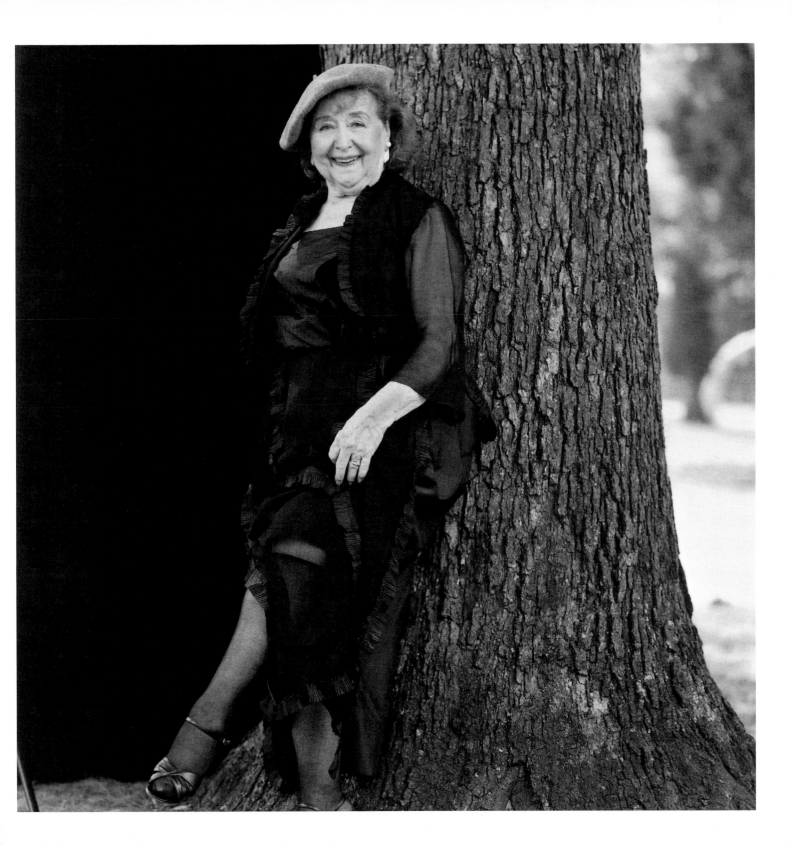

Julia Parker

"I was a happy child until I went to school and was made fun of.
My parents, who were fruit pickers, died when I was seven.
I became an orphan and grew up in a foster home."

"I have learned to stop, look, and listen more.
When I take my time, I have more time, because I have fewer corrections to make."

"*Do the best you can* is the wisest advice I ever received.
Do something you like to do is the advice I give."

"We are all the authors of our own lives, but we cannot write backward.
If you make a mistake, learn and move on.
If something bad happens, accept it and move on."

"Take from the earth with a *please*,
and give back to the earth with a *thank you*."

JULIA PROUDLY WEARS THE GARB OF HER ANCESTORS AND LOVES THE LIFE OF TEACHING THE LOST ART OF BASKET WEAVING. DURING A SEVEN-DAY,
FORTY-HOUR WORK WEEK, SHE RE-CREATES THE PAST FOR VISITORS AT YOSEMITE NATIONAL PARK. JULIA IS THE MOTHER OF FOUR (THREE LIVING),
GRANDMOTHER OF THIRTEEN, AND GREAT-GRANDMOTHER OF TWO. MARRIED FOR FIFTY-THREE YEARS, SHE IS A MEMBER OF THE MIWOK/PAIUTE PEOPLE.
BOTH HER GREAT-GRANDCHILDREN HAVE BLOND HAIR, BLUE EYES, AND AN INDIAN BIRTHMARK PASSED DOWN FOR MANY GENERATIONS.
JULIA IS SEVENTY-THREE YEARS OLD AND LIVES IN YOSEMITE VALLEY, CALIFORNIA.

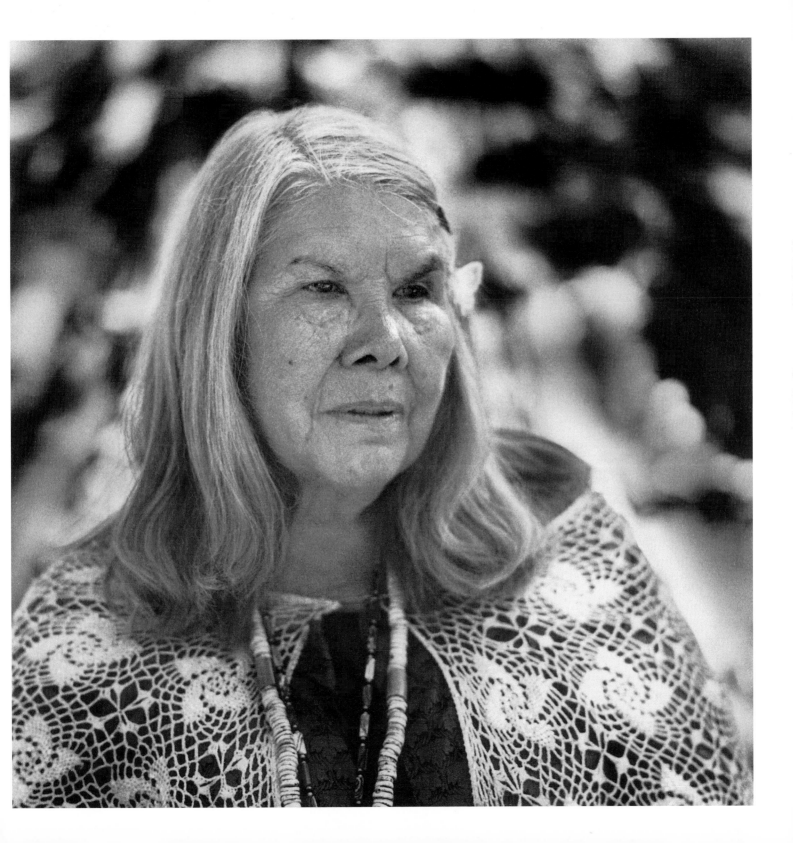

Janet Sackman

"When I was fourteen, I was at the beach when
a man approached me and told me I should be a model.
He gave me his card, and I called thinking it was probably a joke.
It was no joke, and before long, I had the world in my hands.
I was on the cover of *Life* and *Look* magazines
and later became the *Lucky Strike* girl."

"I tell my children one thing over and over:
'Whatever you do, good or bad, it will come back to you.
Do not criticize others or ridicule anyone,
because what you make fun of in others will be yours tomorrow.'"

"When I was diagnosed with throat cancer, I thought it was a punishment for the modeling.
I vowed to God if he would let me live, I would dedicate my life to help others."

"When my voice was taken from me, I became depressed and didn't want to leave the house.
I didn't want to get dressed, always having to hide the hole in my throat.
I went from lively, laughing, and outspoken to a soundless laugh and silent tears.
My husband went everywhere with me. He spoke for me and buffered others' reactions.
People would talk to him and look at me like I wasn't even there:
the cover girl that no one could look at. Such irony."

As a young woman Janet was recognized for her physical beauty. Today she is known for her courage, inner strength, and activism. Speaking is hard. She has taught herself to swallow air into her esophagus and vibrate words. She travels the world with her message of not smoking. When she speaks, everyone listens. Not only has she overcome throat cancer, but a few years later she was diagnosed with lung cancer. Janet works tirelessly for cancer societies and anti-smoking programs. Because of her voice, many rules have changed and many lives have been saved. Married for fifty-one years to her high school sweetheart, she now is taking the same good, loving care of him as he did of her. Janet has four children and eight grandchildren and lives in Hicksville, New York. She is seventy-one years old.

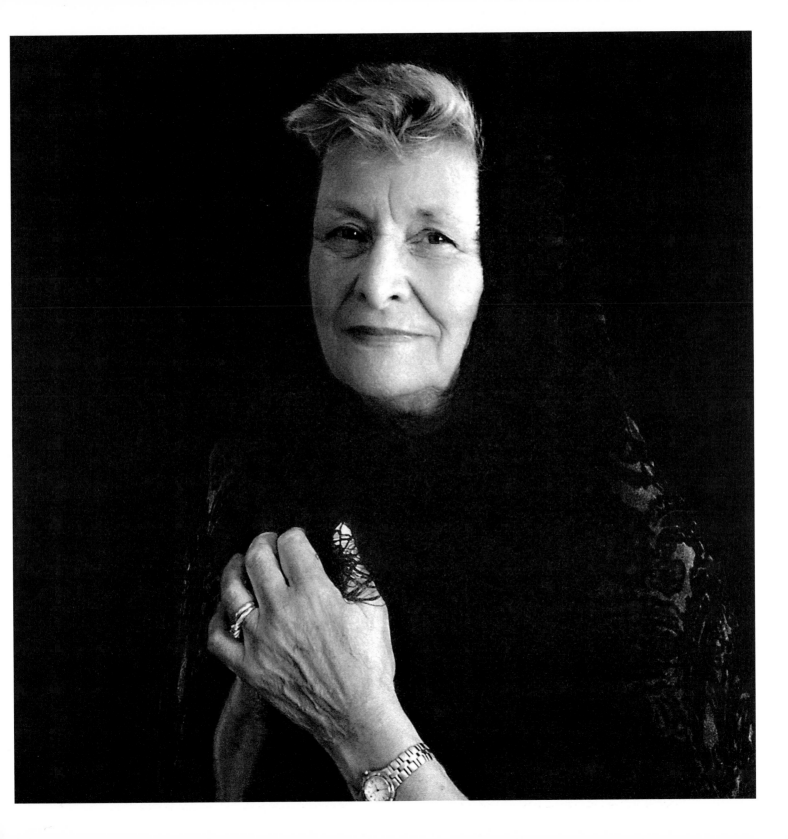

Emily Tefft

"A lesson I learned as a child is if you can't correct something, forget about it."

"One thing I am is a positive person.
I'm positive about what I like and positive about what I don't.
I'm not diplomatic. I say exactly what I think and always have."

"I adore fashion. I dress up every day, and I'm proud to say I do not frequent malls.
People will say to me, 'At your age why are you still shopping so much?'
and I say, 'If I want it, I need it.'"

"I do not like most women. Their high, squeaky voices and
all that 'yackety-yak' cackling give me a headache.
I do, however, like men. They're more frank and forthright."

"Today, people have lost the art of conversation. Politics and more politics—boring."

"I loved the movie *Gone with the Wind*.
I think like Scarlett O'Hara—I'll think about it tomorrow."

"Old people disturb me, so I avoid them as much as I can.
All of my friends are in their seventies."

SALTY, WITH A RAZOR-SHARP HUMOR, EMILY, WHO WAS BORN IN PENNSYLVANIA, WORKS SEVERAL DAYS EACH WEEK AT THE LOCAL HISTORICAL SOCIETY IN NEW MEXICO. WITH DOCENT-LIKE KNOWLEDGE, SHE CAN RATTLE OFF MORE NAMES, PLACES AND DATES THAN ANY ONE YOUNG PERSON WOULD EVER EXPECT TO REMEMBER. ONCE A FIRST-GRADE TEACHER, SHE BECAME A DANCE INSTRUCTOR AT ARTHUR MURRAY AND STILL DREAMS OF RUDY VALLEE AND THE TANGO. MARRIED FOR THE FIRST TIME AT FORTY TO HER BEST FRIEND, SHE IS NOW A WIDOW AFTER THIRTY-TWO YEARS OF A WONDERFUL MARRIAGE. SHE WILL WORK UNTIL SHE IS FORCED TO STOP, WHICH PROBABLY WON'T BE ANY TIME IN THE NEAR FUTURE. EMILY IS NINETY-FOUR YEARS OLD AND LIVES IN SANTA FE, NEW MEXICO.

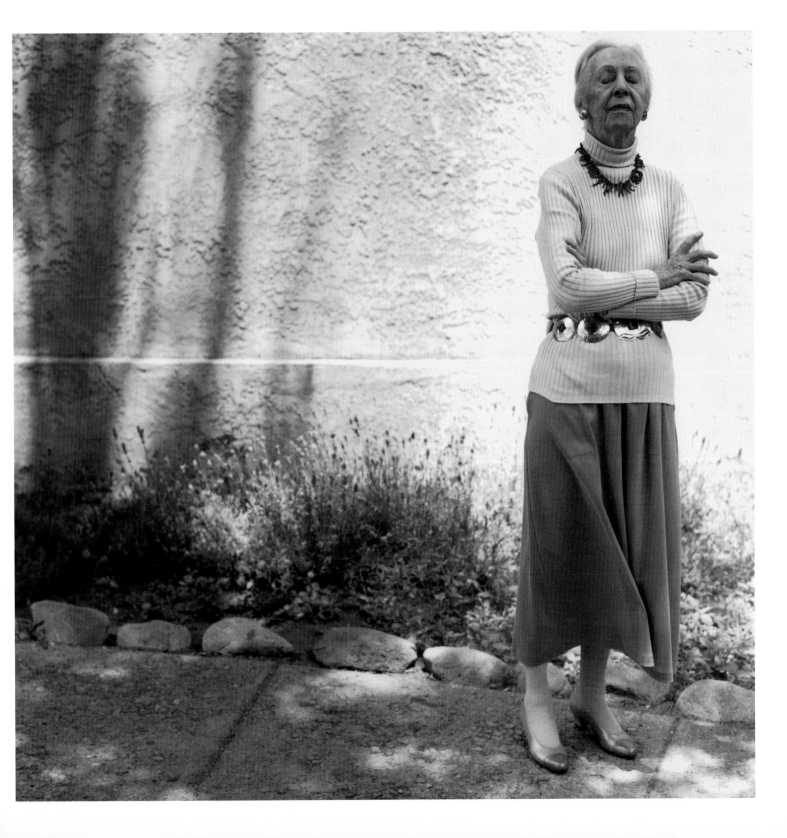

Maryan DeFren

"I was a mischief maker.
I would squirt people with the hose and then hide behind the bushes.
I was always fixing everyone's hair, even if they didn't want me to.
My parents knew I was going to become a beautician
when I gave the family dog a permanent."

"My husband was in bed for years. One night close to the end of his life, he said,
'If I had one wish, it would be that I could dance with you one more time.'
The next night I put the wheelchair in the trunk, and off we went to our favorite nightclub.
As the band played, I jitterbugged around the wheelchair, holding his hand.
Before long, the entire clapping room formed a circle around us.
That was the happiest night of my life."

"The most seductive thing in this world is happiness.
My advice to young girls is *if you don't like yourself, find out why and change it.*"

"I am a saver, and I understand money. I learned early in life the value of a dollar.
I grew up in a house that played poker for entertainment. I learned to play early and well.
Each month when I receive my Social Security check, I head to the table.
I only play with men; it's a game of knowledge, not luck,
but better than knowledge or luck is an understanding of men. They don't watch me, but I watch them.
A woman always plays what she has, and I know when they are bluffing."

A PROFESSIONAL GAMBLER WHO IS BURSTING WITH HAPPINESS AND HUMOR, MARYAN'S LAUGH IS UNFORGETTABLE. A WIDOW WHO HAS MORE MEN PROPOSING THAN MOST WOMEN HAVE LIPSTICKS, SHE FINDS HER HAPPINESS DEEP INSIDE. SHE WAS BORN IN PITTSBURGH. AFTER BEAUTY SCHOOL, SHE BECAME THE OWNER OF THREE SUCCESSFUL SALONS. MARRIED TWICE, THE SECOND TIME FOR TWENTY-EIGHT YEARS, SHE LOVES THE FACT THAT HER GRANDSON TAKES HER OUT ON THE TOWN AND CALLS HER HIS GIRLFRIEND. THIS MOTHER OF ONE AND GRANDMOTHER OF TWO WANTS NOTHING MORE IN LIFE THAN TO STAY EXACTLY AS SHE IS, MINUS FIVE POUNDS. MARYAN IS EIGHTY-TWO YEARS OLD AND LIVES IN LAS VEGAS, NEVADA.

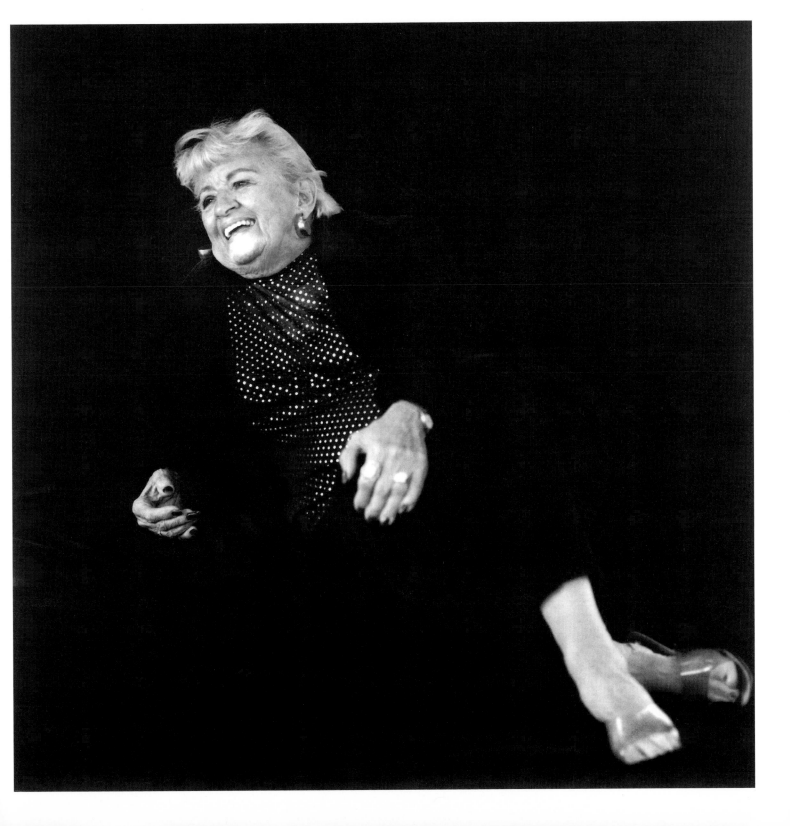

Marie Mariani

"I came from a very cultured family.
My mother was a concert pianist and my father spoke five languages.
I was exposed to good music and fine art from an early age.
I wanted to become an opera singer and would have except for the fact I couldn't sing."

"In my life, I have loved three different men. The first was my husband, whom I loved innocently.
When I found out that he had been cheating on me for years, I learned courage.
The second man taught me to love physically and to become a self-confident woman.
The third, in my later years, taught me to love emotionally and spiritually.
He also taught me that I didn't need a man to be happy."

"There are lots of things I think, but this I know: what you wish for others comes back to you."

"Women are very supportive creatures. Men will cover for each other, share stories,
and even give practical advice. Women, on the other hand, help and encourage one another,
especially when they are in trouble, hurting, disillusioned, and feeling broken.
While I work with both sexes, I have found the intuitive side of the female the most remarkable
part of her nature. Men have the same abilities but trust their instincts less."

"I'm opinionated about everything—politics, medicine, religion, you name it.
If I don't have an opinion, it means that I haven't heard about it."

"I want to keep growing until the day I die, and hopefully, it won't be into the next dress size."

MARIE DOESN'T HAVE A CRYSTAL BALL, BUT YOU MIGHT NOT BELIEVE THAT IF SHE'S READING YOUR CHART. A PROFESSIONAL ASTROLOGER FOR FORTY YEARS, SHE BELIEVES THAT ASTROLOGY IS A TOOL THAT ALLOWS HER TO SEE A HUMAN BEING ON A PHYSICAL, SPIRITUAL, EMOTIONAL, AND PSYCHOLOGICAL LEVEL. SHE DOES NOT PREDICT THE FUTURE BUT DOES HELP PEOPLE TO UNDERSTAND WHO THEY ARE AND WHERE THEIR POTENTIAL LIES. A MOTHER OF THREE AND GRANDMOTHER OF TWO, MARIE HAS ENORMOUS COMPASSION AND USES HER KNOWLEDGE AS A THERAPEUTIC COUNSELOR TO HELP WOMEN WORK THROUGH EVERY PROBLEM UNDER THE SUN. BORN SIX MOONS AND A FEW STARS AGO IN BROOKLYN, MARIE NOW LIVES IN WESTCHESTER COUNTY, NEW YORK.

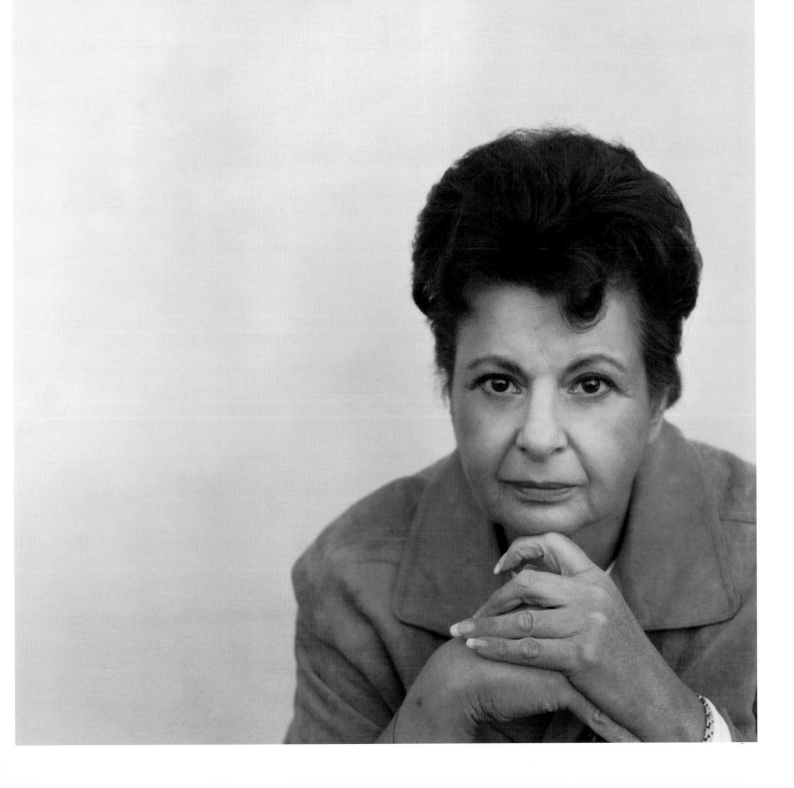

Shirley Thornton

"My first basic training started in our home. I was a girl in a house with four brothers over six-foot-five. My mother made sure I was treated equally and with respect."

"As a youngster, I was taught the difference between the words *can't* and *won't*. I was also taught that the harder you work, the less luck you'll need."

"In the military, I learned that I may not be as smart as some folks, but I wasn't as dumb as the folks who thought they were so smart."

"In high school, I desperately wanted to become a teacher. My counselor told me that as a black woman that world was not open to me. I was told that I had a good voice and should concentrate on becoming a singer. I became the principal of that very school."

"No matter what I do, people know that I've been there. I show people. I don't tell them."

"In today's world, we need more understanding of what it means to be responsible for having children. Having kids is like having a garden. You can't go on vacation and not prune and water your plants without the weeds growing wild."

"When people look at me and say, 'I don't think of you as a woman or as an African American,' I would love to know what they see. Yes, I find fault in paradise. If they don't see those things, then they have missed my essence—all the pain and struggle that have gone into creating me."

"Much more work needs to be done, and the answer is education."

WITH A NICKNAME LIKE "THE HAWK," SHE SEES EVERYTHING AND NOTHING FLIES OVER HER HEAD FOR LONG. SHIRLEY, WHO WAS BORN IN NEW ORLEANS, HAS HAD TO FIGHT EVERY INCH OF THE ESTABLISHMENT IN ORDER TO CHANGE IT. SHE MARRIED FOR FIVE YEARS AND DIVORCED. ALTHOUGH SHE DOES NOT HAVE CHILDREN OF HER OWN, SHE IS A MOTHER FIGURE TO THOUSANDS. AT EIGHTEEN, SHE JOINED THE ARMY AND RETIRED AS A FULL COLONEL. WITH DUAL CAREERS, SHIRLEY EARNED A DOCTORATE IN EDUCATION AND IS PRESENTLY NATIONAL DIRECTOR OF AMERICA'S SCHOOLS PROGRAM. SHE TURNS AROUND EVERY PUBLIC SCHOOL SHE ENTERS. SHE IS A ONE-WOMAN COMMANDO UNIT WHO DOESN'T TAKE NO FOR AN ANSWER AND DOESN'T GIVE UP UNTIL HER MISSION IS ACCOMPLISHED. ALONG WITH CHANGING THE SCHOOL SYSTEM IN THE UNITED STATES, SHE WORKS ON REFORMING EDUCATION PROGRAMS IN THE PRISON SYSTEM. SHIRLEY'S LIFE IS A WORKING PRAYER AND SHE HAS EARNED THE RESPECT OF ALL WHO WELCOME POSITIVE CHANGE. SHE IS SIXTY-THREE YEARS OLD AND LIVES IN NORTHERN CALIFORNIA.

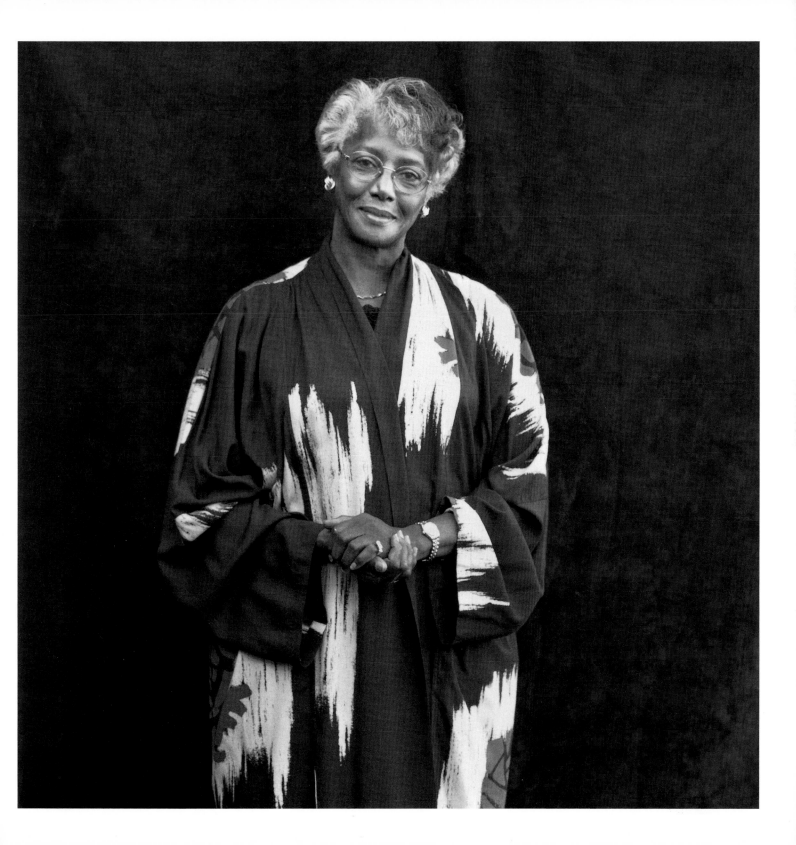

Carolyn Horan

"Our family was poor, but I was a happy secondhand Rose.
It was Christmas and all my friends were getting new bicycles. I got one too.
My dad took apart an old bike and hand-painted it. It had new tires and a bell.
I was so proud of that bike, but not nearly as proud as I felt about my father."

"It has to be 'I love you as you are.'
I married a man who was perfectly happy to let me have all the freedom
I wanted to pursue my career and make my own decisions.
I also married a strong, silent man who did not want to participate in many things I was involved in.
If I wanted an unhappy marriage, I would have nagged him to change."

"Women's liberation has liberated men as much as women."

"I dislike having fears, both mental and physical, so I confront them.
I remember being terrified to ride on a chair lift while skiing; my friend was yelling,
'Don't look down!' I never forgot that warning. It's like don't look back, just keep on going.
The secret formula is to move ahead carefully, one step at a time.
That way, nothing is insurmountable."

"I always believe that just around the corner something good is waiting for me."

SHOCKING EVERYONE WHO THOUGHT HER CONSERVATIVE, CAROLYN CAREFULLY ZOOMS AROUND THE HILLS OF NORTHERN CALIFORNIA.
INDEPENDENT AND INTELLIGENT, SHE IS ONE DETERMINED LADY. AFTER HAVING TWO STILLBIRTHS AND THREE CHILDREN, SHE WENT BACK TO SCHOOL
AT NIGHT AND GOT HER B.A. AND MASTER'S DEGREES. DIVORCED ONCE, SHE HAS NOW BEEN MARRIED FORTY-TWO YEARS. IN HER SPARE TIME, SHE BIKES,
GOLFS, AND RIDES HORSES. ONCE A TEACHER AND SUPERINTENDENT OF SCHOOLS, TODAY SHE RUNS THE BUCK INSTITUTE, AN EDUCATIONAL RESEARCH FIRM.
CAROLYN HAS RECENTLY BEEN HONORED AT THE MARIN COUNTY WOMEN'S HALL OF FAME. SHE IS A RECENT BREAST CANCER SURVIVOR,
AND IS THE MOTHER OF THREE, GRANDMOTHER OF THREE, AND GREAT-GRANDMOTHER OF TWO. CAROLYN IS SEVENTY-ONE YEARS OLD.

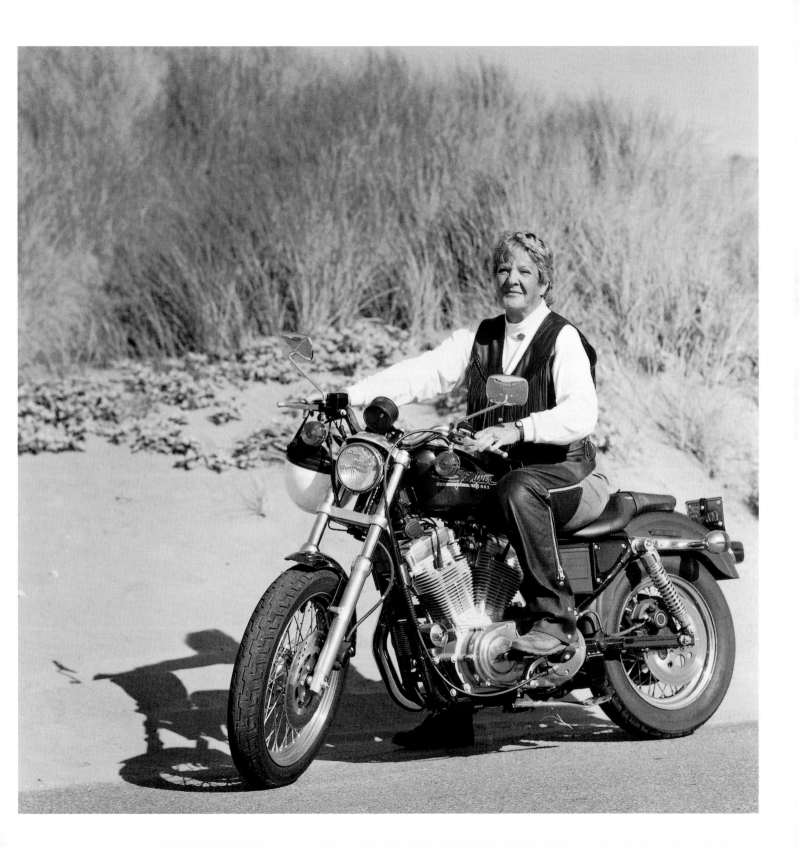

Grace Parsons

"I've survived a nervous breakdown at fifteen, stomach and breast cancer,
the rearing of three children, the death of a husband, and two divorces.
What's next is what I'd like to know."

"I never took any nonsense from the men in my life.
I guess you could call me a fighter. 'Tow the line or out the door' is my motto."

"When my alcoholic husband demanded
that I tell him my New Year's resolution in July, it suddenly hit me.
I told him that I was going to get rid of him, and I did."

"After the divorce I heard he told a friend of his that I was dead.
Well, I dressed up the corpse, took her out and killed that rumor."

"I hope I die working. I dislike lazy people and dirty houses.
My idea of a good time is picking weeds and planting bulbs.
I like a cocktail now and then, but nobody
would ever accuse me of being at the other end of a bourbon bottle."

"I used to like men under the covers. I now prefer them on top."

GRACE IS A BORN SURVIVOR, A FARMER'S DAUGHTER WHO TELLS IT LIKE IT IS. NO ONE IN THE SMALL TOWN WHERE SHE LIVES IS SURPRISED TO SEE HER
CLIMBING THE LADDER, BUCKET AND SCRUB BRUSH IN HAND, AND DARING THE LIGHT NOT TO SHINE THROUGH THE WINDOWS OF HER OLD FARMHOUSE.
RUNNING A BED AND BREAKFAST, WHEN THE SPIRIT MOVES HER, KEEPS THIS TRUE YANKEE WOMAN ON HER TOES. SHE HAS TRAVELED ALL OVER THE WORLD
BUT HAS LIVED HER ENTIRE LIFE IN NEW ENGLAND. MARRIED THREE TIMES, SHE HAS THREE CHILDREN, TWO GRANDCHILDREN AND ONE GREAT-GRANDCHILD.
GRACE NEVER MISSES A GARDEN CLUB MEETING AND ENJOYS A GOOD STORY AND A LITTLE HARMLESS GOSSIP.
SHE IS EIGHTY-SIX YEARS OLD AND LIVES IN BETHEL, CONNECTICUT.

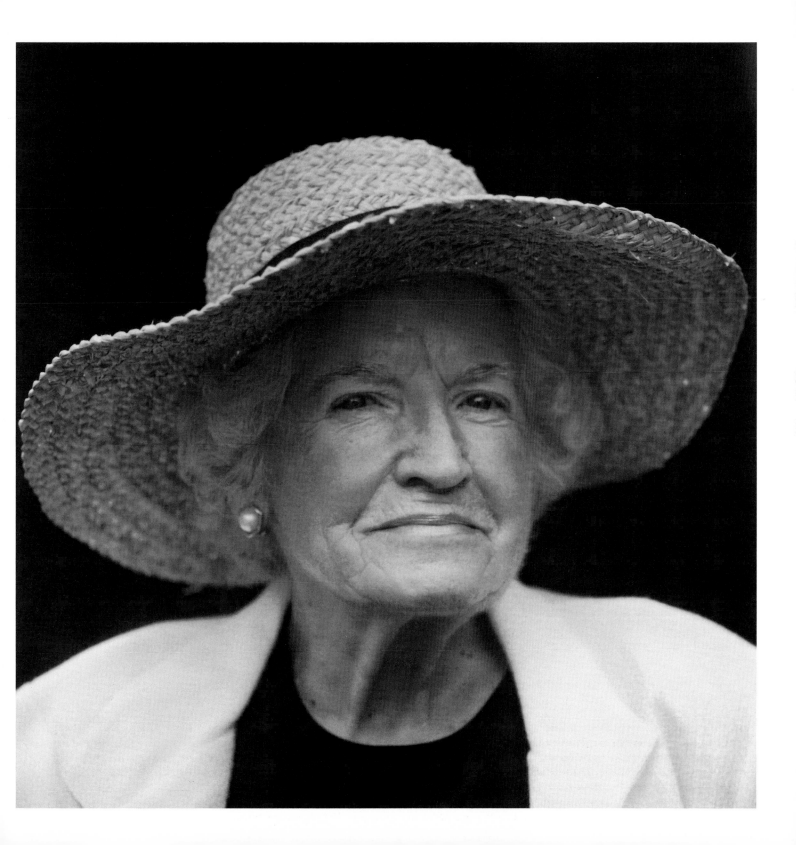

Olga Steckler

"When I was a little girl, I was afraid of ghosts.
Now I spend a great deal of time talking to them."

"When I first got involved in modeling,
I was told that I was too good, too trusting, and too friendly.
They told me to wise up. Time proved them wrong."

"When Lenny left me for a younger edition everyone was surprised.
I think what surprised them most was I wasn't terribly upset. We had a wonderful marriage
and then he went through a midlife crisis—grew his hair long,
changed the way he dressed and started acting out—he really went nuts.
What was there to miss—I didn't know who he was anymore.

"I live alone, but I am never lonely.
You see, I am a planner. I do my research and find out what is going on in town.
Because of that I always have something to look forward to."

"This may seem surprising to some people, but I'm glad I never had children.
The way the morals have changed, I would have been dead with worry long ago."

"I make love every night.
Sometimes it's to a good book. Sometimes it's to a bubble bath."

IF MEMORIES WERE MONEY, OLGA WOULD BE A RICH WOMAN. DURING WORLD WAR II, SHE WAS THE COVER GIRL ADORNING MANY A SOLDIER'S LOCKER.
HER FACE WAS FEATURED ON EVERYTHING FROM BOXES OF OREO COOKIES TO ADS FOR BUDWEISER BEER. SHE WON THE TITLE "MISS VICTORY OF BOSTON"
AND NUMEROUS BEAUTY CONTESTS. DIVORCED AFTER TWENTY YEARS OF MARRIAGE, TODAY SHE DOES "ODD JOBS," WORKS AT THE NATIONAL ARTS SOCIETY
AS A RECEPTIONIST, HELPS ELDERLY NEIGHBORS WITH DAILY CHORES AND, OCCASIONALLY, SELLS VINTAGE ART. HER CALENDAR IS FULL—THE BALLET,
SYMPHONY, THEATRE, AND OLD FRIENDS COMING TO VISIT. THE WALLS OF HER APARTMENT ARE CRAMMED WITH THE EVIDENCE OF A GLAMOROUS LIFE.
THE PORTRAIT IN THE BACKGROUND IS OLGA AT TWENTY-THREE. TODAY, SHE IS EIGHTY YEARS OLD AND LIVES IN MANHATTAN.

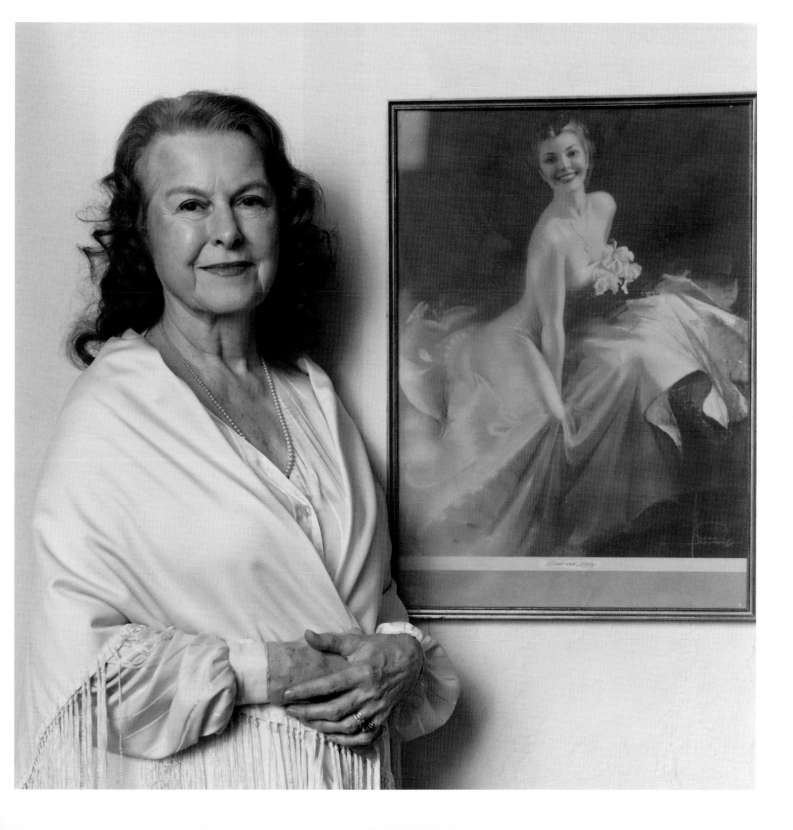

Gilda Manzi

"My mother died when I was four.
My father married her sister. Then she died too.
I lost two mothers before I became a teenager. That was hard."

"I married for the first time when I was seventeen.
His father didn't like me because I had a mind of my own.
So he sent my husband back to Italy. I thought my life was over,
and I wanted to die . . . but I'm glad I didn't."

"My sister had to go to a friend's funeral and didn't want to go alone.
I didn't want to go, but I couldn't turn her down.
It was there that I met Michael, the love of my life. It pays to be nice to your sister."

"My job was to find people who didn't want to be found.
I guess I fancied myself as a female Dick Tracy or Robin Hood.
I tracked down more than a few scoundrels in my heyday.
And none of them were very happy to hear from me."

"Life is funny, no, sad. When I was a girl, a woman couldn't wear pants.
Today, too many women can't wait to take their pants off, for men they aren't even married to."

You can run, but you can't hide from Gilda. She is a spitfire, carrying her four-foot-ten frame with self-assured dignity. Just recently, she retired from a fifty-year stint as a private investigator, tracking down bad guys with a computer and a telephone. Gilda was raised in New York City by her Italian immigrant parents. A widow who was married forty-eight years, Gilda has two daughters, four grandchildren, and six great-grandchildren. She intends to spend the rest of her life shopping. She is ninety-one years old and lives in New Jersey.

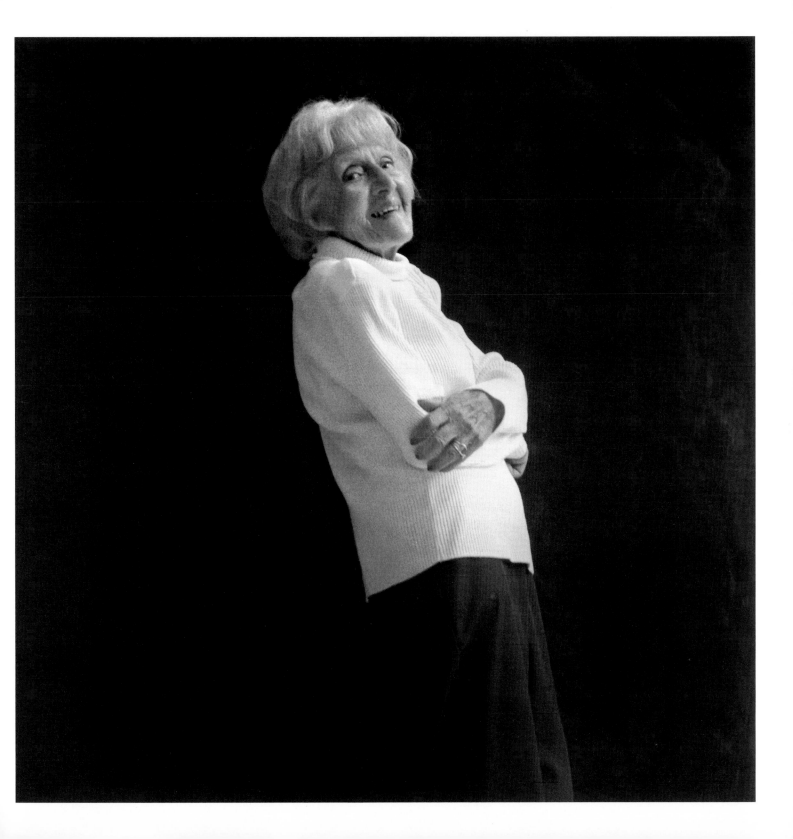

Juliane Biro

"My mother saw the writing on the wall before the Holocaust
and sent me to live at a Catholic home for children in England. I was eight years old."

"Today, I am ethnically Jewish, emotionally Catholic,
and still searching for meaning to the mystery of life.
No one has the answer to who or what God is.
I believe that all religion is a telephone line to the same destination."

"I never give criticism unless it hurts me to do it.
For me, helping others is selfish, it feels that good."

"The tragic events of September 11 gave us all an underlying sense of vulnerability.
It made me more aware of the isolationist tendencies here in this country,
not only politically but educationally.
We need to understand, listen to, and respect other nations, just as we would like them
to understand our point of view. If we don't, history is bound to repeat itself."

"Fairy tales are wonderful and in a very real way, they are symbolic of what we want
from life . . . good always triumphs, little guys win, and the weak become the strong."

As a child, Juliane survived the Holocaust thanks to the miracle of the Kindertransport, a group that saved the lives of many Jewish children. Born in Germany, Juliane has lived her adult life in New York. Today, widowed after forty-one years, Juliane is a librarian who is passionate about her love of reading and especially enjoys working with children. The mother of one son, she is a facilitator and translator for the local Spanish community. Juliane runs origami groups and is pictured with one of her husband's sculptures. She is seventy-two years old and lives in Westchester County, New York.

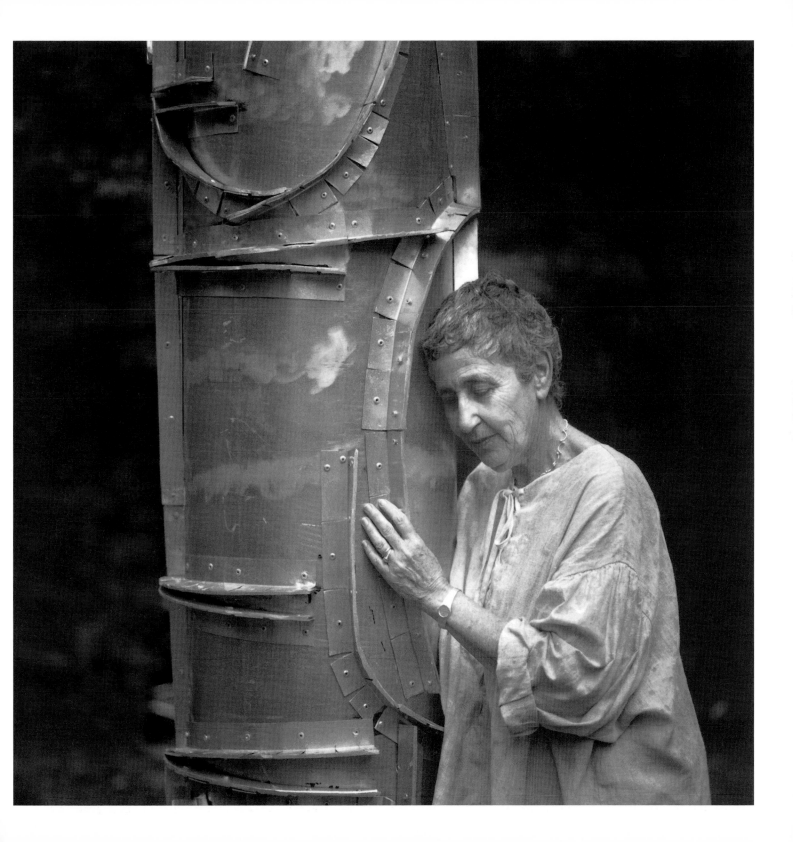

Mary Hammond

"I grew up the daughter of a German butcher, in a house filled with
sadness and guilt. My sister died a few years before I was born.
They didn't talk about her, which made it worse.
I spent my childhood trying to make up for the fact I was alive and she wasn't."

"When I was twenty-one years old, I made a wish list for my life.
I wrote down all my goals. One was to get a date with a boy who had no interest in me.
All my goals were met, including marrying that boy who didn't know I was alive."

"I got fired once. They said I acted unprofessionally.
I bought lottery tickets for the mentally ill patients at the hospital where I worked.
I think a lot of them would have recovered quickly if we had won."

"Children today are sitting in front of boxes
instead of running around the block and climbing trees.
In some respects, our society has turned normal children into handicapped ones."

"Divorce is a terrible thing. It tears a family apart.
Looking back, I wish I had done more to save my marriage.
We could have tried harder and worked it out.
I thought I needed to leave to grow. But I was wrong."

A California girl who calls herself just a kid from Sheboygan, Mary is a dilettante in the best sense. Nothing keeps her down for long. Married for twenty-five years and divorced, she has been an occupational therapist, potter, bartender, waitress, masseuse, and housekeeper. Mary rents out her house when she needs extra money. Once, in between careers, she took off for Japan and taught English. The mother of three and grandmother of five enjoys tennis, golf, skiing, and travel. She has no idea what she will do next, but she knows it will be fun. Mary is sixty-eight years old and lives in Northern California.

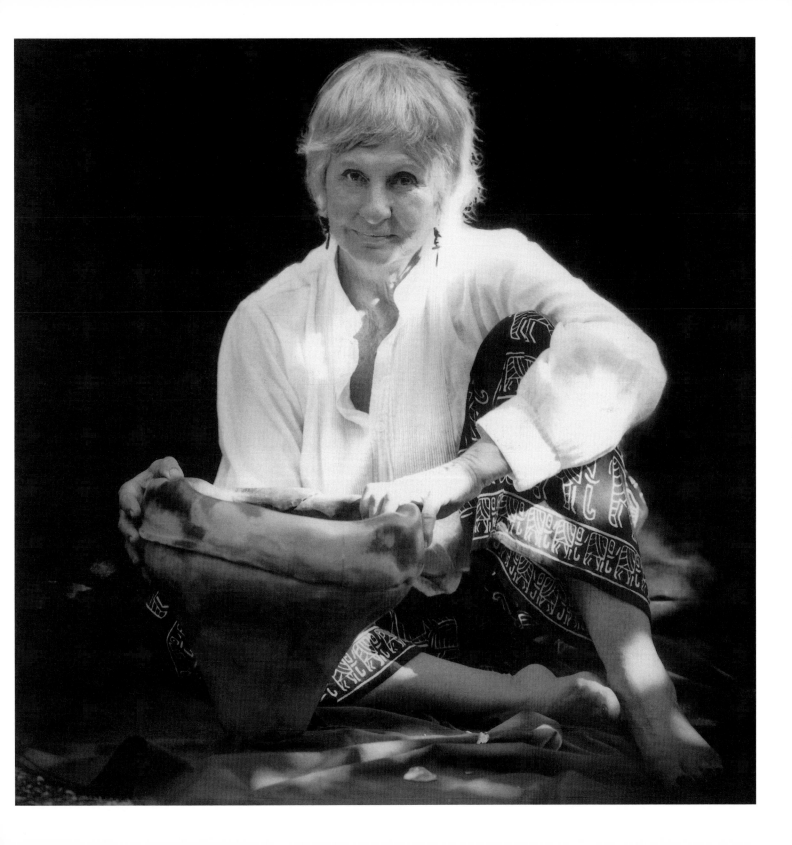

Ellen Fitzpatrick

"When I was a little girl,
I would fall asleep dreaming that one day I would become a forest ranger.
For years I thought that my dream could only be a fantasy."

"I like my men and my meals big.
Eat with gusto, work with gusto and love with gusto."

"I accept myself completely. I never look in the mirror.
Forget about fat, skinny, blond, brunette, redhead.
None of that makes any difference. What is seductive is enthusiasm."

"My husband of forty years is still my hero, and I'm still his girl.
It's a beautiful thing to get old with someone you love."

"There haven't been any obstacles in my competing in a man's world.
I quietly do my job to the best of my ability and enjoy bringing out the best in others."

"As far as getting on in years . . . heck . . . I'm ageless in my black Mustang.
It's old and I'm old."

A GUY'S GIRL WHO IS COMFORTABLE IN HER OWN SKIN, ELLEN IS TENACIOUS. WHEN HER HUSBAND OF 40 YEARS HAD BYPASS SURGERY, ELLEN REFUSED
TO LEAVE THE HOSPITAL, GOING AS FAR AS HIDING IN THE CLOSET UNTIL THEY GAVE IN AND LET HER STAY BY HIS SIDE. THE MOTHER OF SIX AND
GRANDMOTHER OF FIVE, ELLEN HAS BEEN A PRESCHOOL TEACHER, FOSTER PARENT, WELDER, AND VAUDEVILLE ACTRESS.
SHE DESCRIBES HERSELF AS "HEALTHY AS A HORSE" AND DAILY ENJOYS THE FACT THAT HER CHILDHOOD DREAM CAME TRUE, IN SPITE OF MANY OBSTACLES,
JUST IN TIME FOR HER SIXTIETH BIRTHDAY. BORN IN LOS ANGELES, SHE NOW CALLS ARIZONA HOME. SHE IS SIXTY-FIVE YEARS OLD.

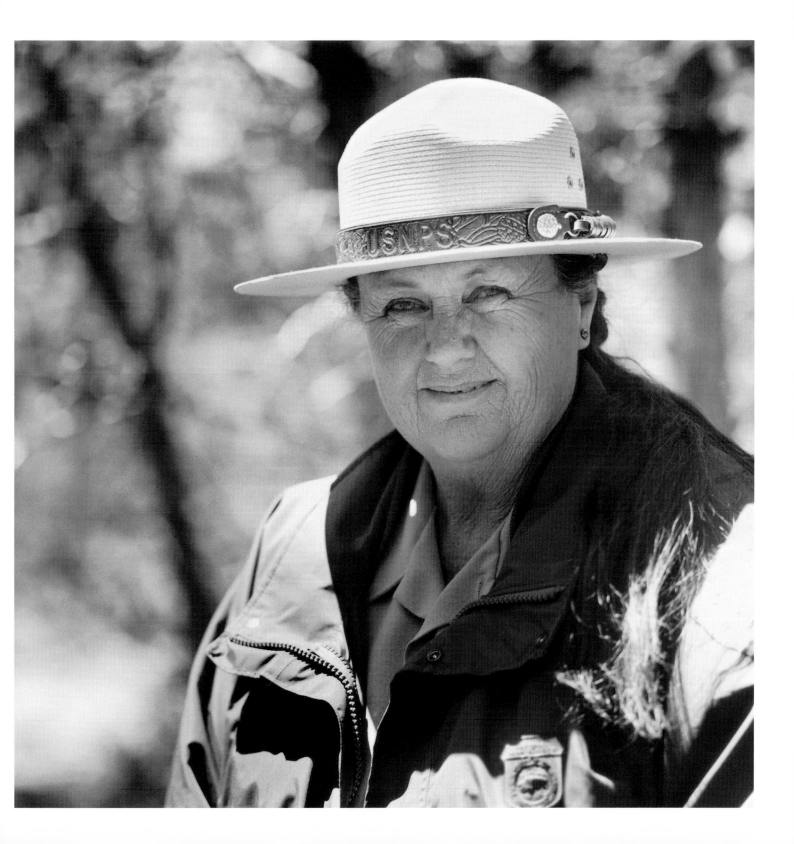

Daphne Lewis

"When I was four years old, I was living with my parents at Pearl Harbor.
I remember the day we were attacked.
My mother shoved me under the bed and was screaming for me to be quiet.
I remember the face of our Japanese nanny when she said goodbye.
Some things stay with you forever."

"I've always been the first of my friends to do things.
I was the first to get married, the first to get divorced,
and the first to become a grandmother.
I don't want to be the first anymore."

"The happiest day of my life was also the saddest.
My ex-husband, who remained one of my best friends,
died of a heart attack the night our granddaughter was born.
Whoever said life is stranger than fiction knew what they were talking about."

"I play with the hand that I am dealt.
When my son told me he was gay, I was terrified.
All I could think of was that he was going to die.
Like everything else that happens in life, I got over it."

"I have learned not to judge anyone.
Because everything I said I'd never do, I've done twice."

No Nana or Grandma for Daphne . . . feeling the family could use some royal blood, she decided her granddaughter
should call her "The Countess." Daphne's quick wit and sense of humor make her the one person everyone wants to have at the party.
After earning a business degree later in life, she opened the successful recruiting company she runs today. She has lived alone for over
thirty years and is as fit and beautiful as a forty-year-old. Daphne hikes, plays tennis and makes plenty of time for her three children and
granddaughter. She is sixty-six years old and lives in San Francisco.

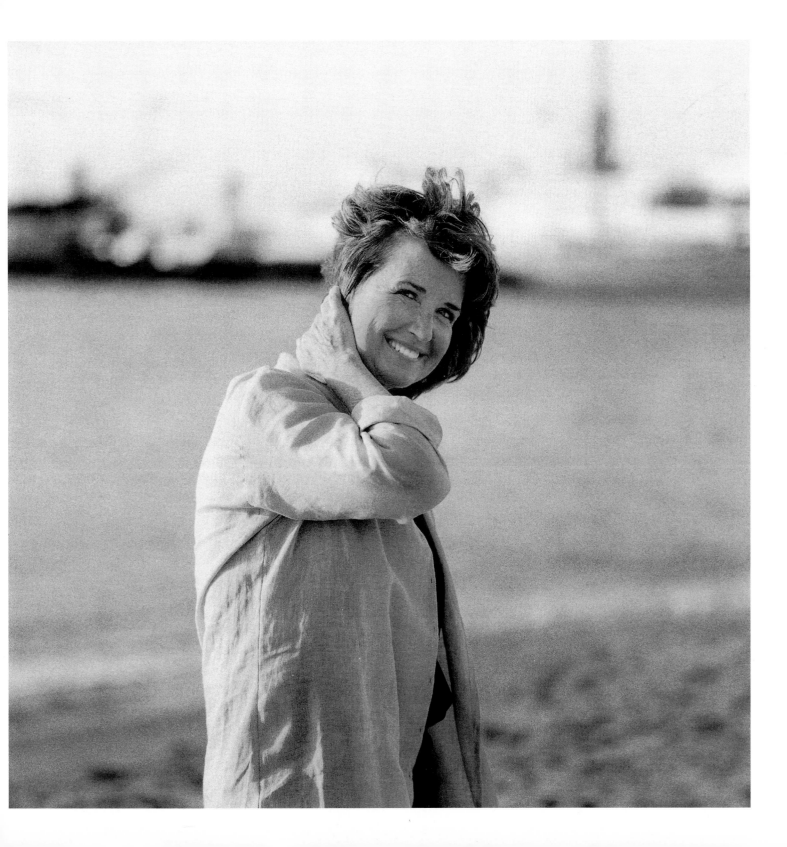

Anna Hessler

"I was born with red hair and an entire body filled with freckles.
They used to say that if you got up early in the morning and washed yourself with
mountain dew, your freckles would go away. What a silly girl I was."

"Being a telephone operator was great fun. I would make a game out of all the calls.
I would compete with myself to see how fast I could put them through.
And back then a long distance call would often take half the day.
What a thrill it was when a foreign voice finally came on the line."

"My love story is quite unusual, I think.
I met my husband at the telephone company, where we both worked.
He was shy, and I was a bit of a devil. He was six-foot-four, and I was a little bit of a thing.
The first problem was religion. I was Catholic, and he was Seventh-day Adventist.
My mother did not care for him, so the marriage was put on hold. The second problem
was his mother, and she suddenly became quite ill and stayed that way for years.
Every time I thought we would get married another
problem occurred . . . on and on and on and on it went.

"Leaving him wasn't an option. I was in love, so we laughed and square-danced the years away.
His mother died, then my mother died. I remember the night he asked me to
marry him . . . they're all dead, he said, we can get married now.
We only had eight years, but they were happily-ever-after years."

ANNA BECAME A BRIDE FOR THE FIRST TIME AT SEVENTY, AFTER DATING HER HUSBAND FOR THIRTY-FOUR YEARS.
SHE RETIRED FROM THE TELEPHONE COMPANY AFTER FORTY-FIVE YEARS, AND I PROMISE YOU THAT IF YOU EVER REACHED HER VOICE, IT MADE YOUR DAY.
HER ENTIRE LIFE WAS SPENT IN DELAWARE, OHIO, BUT HER IMAGINATION ALWAYS LIVED IN THE WILD WEST. HER PASSION FOR READING NOVELS, AT LEAST
FIFTEEN EACH MONTH, GREW OUT OF HER DESIRE TO LEARN HOW LIFE WAS IN COWBOY COUNTRY. SHE HAS LOST HER HEARING AND MUCH OF HER EYESIGHT
DUE TO A STROKE, BUT HER SENSE OF HUMOR IS AS PENETRATING AS ANY BULLET FLYING OUT OF WYATT EARP'S REVOLVER. ANNA IS NINETY-FIVE YEARS OLD.

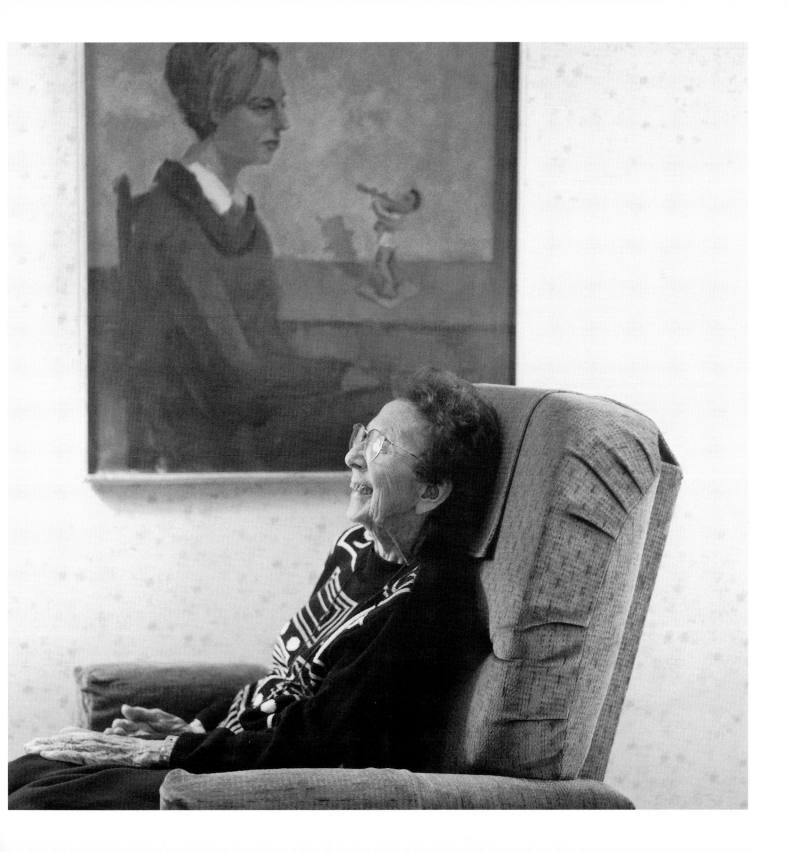

Sally Ryan

"I think people are born the way they are, and I was born happy. I was always able
to look at the good side of things. I had such a marvelous upbringing. There was always a sense
of gaiety, family vacations and wonderful conversation."

"The hardest part of marriage is staying married.
Madly in love has to turn into loving respect. Sometimes after being with the same person for years,
no matter how happy you are, you get tired of hearing the same old stories and jokes over and over again.
Sometimes you wish you could just be someplace else."

"All that said, when my husband passed away,
I would have given years to hear one of those old jokes."

"My generation didn't talk about sex; they certainly didn't tell us how wonderful it was."

"Like yesterday, I remember my daughter chasing my car, begging me to take her shopping.
With five children, I wanted to be alone. Years later, after she passed away,
I would think of all the things I wish I had done differently. Sometimes the best part of life is savoring sorrow."

"Life has a way of giving us exactly what we need, whether we like it or not.
In the end, everything works out exactly the way it's supposed to."

SALLY IS WISE, FUN LOVING AND SPIRITUAL—A CROSS BETWEEN PLATO AND POLLYANNA. BORN INTO A MUSICAL ACTING FAMILY
IN NEW YORK CITY, SHE HAS STAYED CLOSE TO HOME, RAISING HER FAMILY IN NEW JERSEY WHILE WORKING AS AN EXECUTIVE SECRETARY.
A FIRM BELIEVER IN EDUCATION, SHE USED HER INCOME TO MAKE SURE HER CHILDREN HAD THE OPPORTUNITY FOR A COLLEGE EDUCATION.
SEVERAL YEARS AGO HER MIDDLE DAUGHTER DROWNED (LEAVING THREE OF HER GRANDDAUGHTERS MOTHERLESS). SALLY'S FAITH
AND REFUSAL TO LET THIS TRAGEDY DO ANYTHING BUT BRING HER FAMILY CLOSER IS INDICATION OF HER STRONG WILL. A WIDOW WHO
WAS MARRIED FOR FIFTY-SEVEN YEARS, SHE IS THE MOTHER OF FIVE, GRANDMOTHER OF TWENTY, AND GREAT-GRANDMOTHER OF THREE. TODAY, SALLY
SPENDS TIME TAKING CARE OF FAMILY, PLAYING BRIDGE, AND IMPROVING HER GOLF GAME. SHE IS EIGHTY-TWO YEARS OLD AND LIVES IN SARASOTA, FLORIDA.

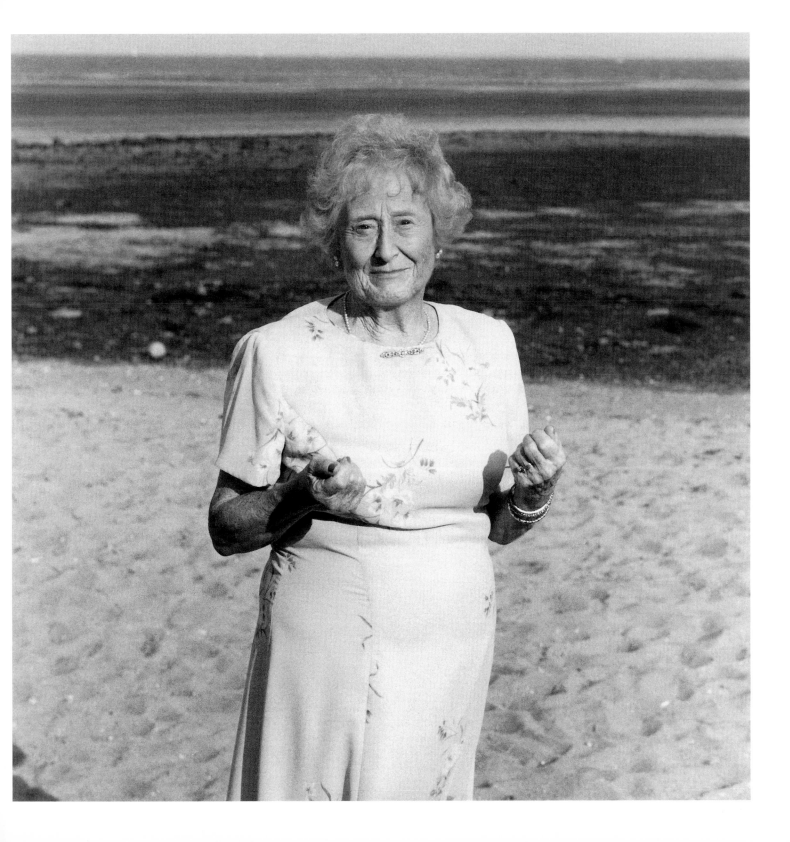

Antonia Pena

"As a child I remember a young man coming to our door pleading for milk for his children.
After he left with his arms filled with food, my father said to me,
'If that man had stolen to feed his children, it would not be wrong.'
My interest in social justice was born that night."

"On her deathbed, my mother made my father promise to make sure I got a college education.
She said, 'You can take many things away from a woman, but not her education.'"

"Women of my generation are a bridge generation.
We saw our mothers begin, during the Second World War, to assume new roles.
It was our generation that laid the foundation for the movement of the next."

"I was the last person anyone expected to go into religious life. I was outspoken, liberal, and rebellious.
I loved my life in the convent and believe that the nuns were the first feminists.
Deciding to leave after thirty-seven years was an enormous loss and terribly painful.
I no longer believed in the hierarchy, and my personal integrity was at stake."

"How little rest and silence people seek . . . the cell phones, the sixteen-hour days, and their pagers and computers.
When people lose the ability to feed their souls and families, society in general is the loser."

"Success in life is knowing that you have tried your best to be who you really are.
And in doing so you have helped others. There is nothing I would change ... joyous, painful, positive, or negative.
It all came together to make me who I am."

ANTONIA DOESN'T HAVE A VAGUE BONE IN HER BODY. SHE IS A SOCIAL ACTIVIST WITH A PASSION AGAINST ANY KIND OF INJUSTICE.
SHE HAS STRONG OPINIONS AND HAS NO PROBLEM VOICING THEM. BORN IN NEW YORK CITY TO SPANISH PARENTS, HER MOTHER DIED OF TUBERCULOSIS
WHEN ANTONIA WAS SEVENTEEN. AFTER SHE ENTERED THE CONVENT, HER FATHER DIDN'T SPEAK TO HER FOR THREE YEARS. THEY EVENTUALLY RECONCILED
AND HAD A LONG WONDERFUL RELATIONSHIP. SHE HAS TAUGHT AT THE ELEMENTARY, HIGH SCHOOL, AND UNIVERSITY LEVEL. ANTONIA HAS BEEN
ACTIVE IN THE PEACE MOVEMENT, LATINO AND AFRICAN AMERICAN STUDENT MOVEMENT, AND OTHER SOCIAL REFORM ACTIVITIES. IN HER SEVENTIES SHE
WAS THE FIRST FEMALE ROMAN CATHOLIC CHAPLAIN AT YALE UNIVERSITY. TODAY SHE LEADS A SIMPLE LIFE CARING FOR AN ELDERLY RELATIVE AND
IS ACTIVELY PURSUING NURSING HOME REFORM. ANTONIA IS SEVENTY-THREE YEARS OLD AND LIVES IN QUEENS, NEW YORK.

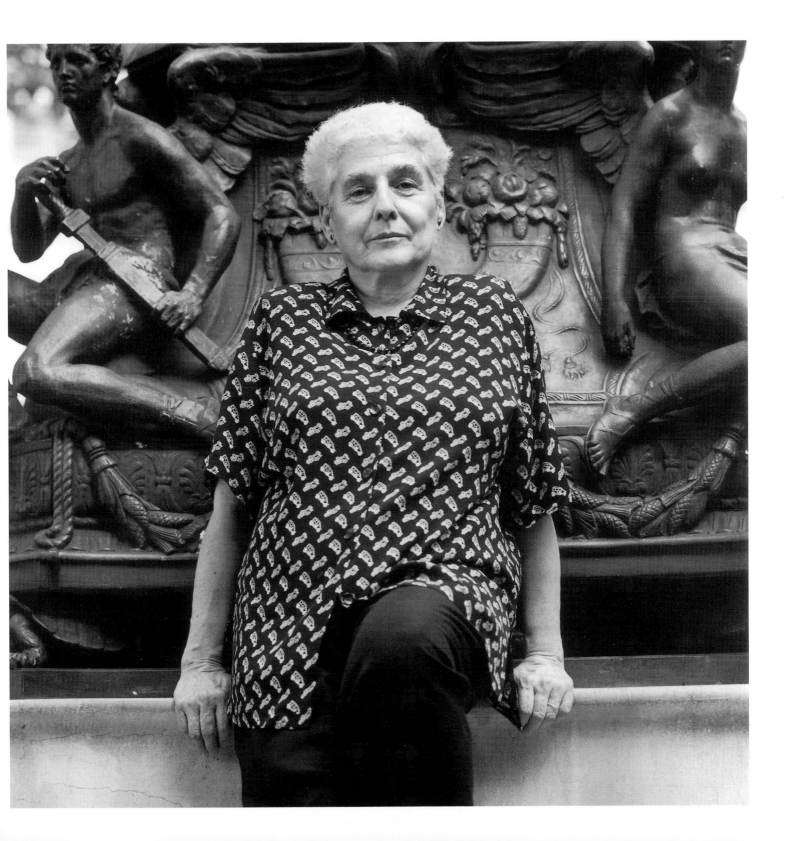

Louann Nockels

"My family says that I started running away as soon as I could walk.
I never looked at it as running away. I always felt that I was running toward something new."

"I was taught that life was difficult and had to be endured.
Fortunately, I was not an obedient student."

"Over the years, I have learned that I am not as unusual as I once thought I was.
I was trying to be unique, but I was a phony. I now look at myself as being like a lot of other people.
My ego doesn't need to be different anymore, and that is freeing."

"My daughters think the women's movement went too far.
I think it didn't go far enough. Women in my generation were taught to find a man to take care of them.
They were expected to breathe, think and walk like the person they were married to.
They got security at the price of giving up freedom."

"What I don't like about getting older is that there
is very little information on what to do next. I thrive on change and never want to become
a living dead person. The media is still talking to older people like they're old.
I don't think society is ready for the generation that is about to come."

"When I was younger and looking up the mountain, it often seemed insurmountable.
Going down is wonderful, knowing that I made it to the top."

DEEPLY INTROSPECTIVE AND HONEST, LOUANN IS THE EPITOME OF THE WHOLESOME GIRL NEXT DOOR. SHE HAS LIVED IN ILLINOIS, IDAHO,
AND CALIFORNIA. A DOCTOR'S WIFE FOR TWENTY-FIVE YEARS, SHE LEFT TO FIND HER OWN SPACE. ALWAYS WANTING TO LEARN SOMETHING NEW
AND EXPERIENCE SOMETHING DIFFERENT, LOUANN TAUGHT ENGLISH AND HISTORY IN TURKEY AND POLAND. WITH A B.A. IN THEATRE ARTS AND AN M.A.
IN PSYCHOLOGY, SHE BECAME A DRAMA THERAPIST FOR SEVERAL YEARS. PRESENTLY, SHE WORKS WITH CANCER PATIENTS AND PEOPLE RECOVERING FROM
DISABILITIES IN HER PERSONAL TRAINING BUSINESS. THIS MOTHER OF THREE AND GRANDMOTHER OF FOUR IS HOPING TO GET TIME OFF SO SHE CAN
TRAVEL AROUND THE WORLD. LOUANN IS SIXTY-SEVEN YEARS OLD AND LIVES IN SAN FRANCISCO.

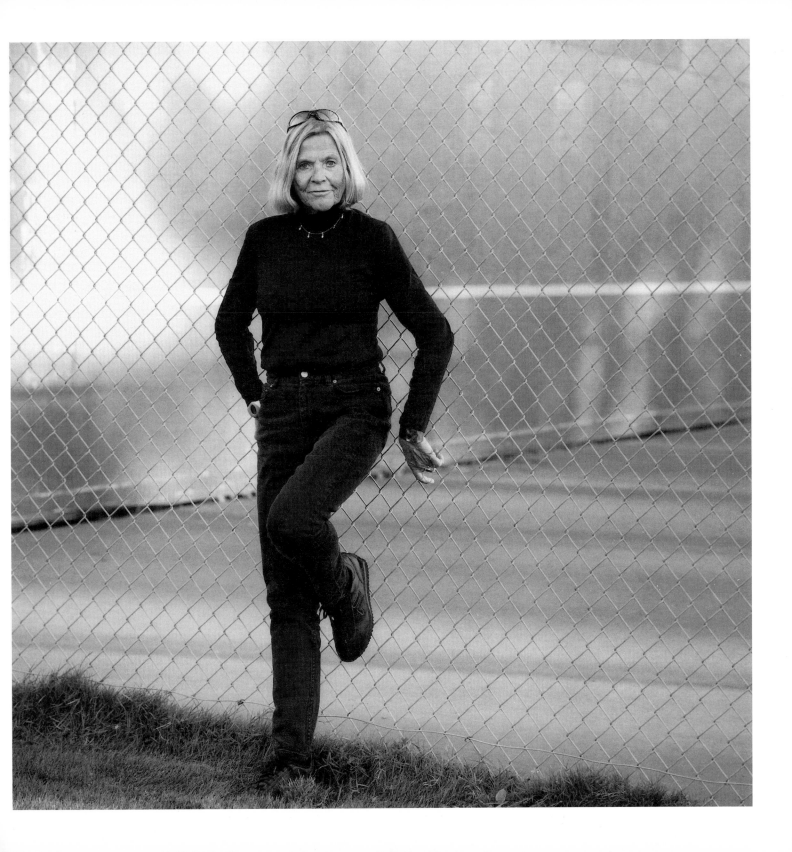

Dorothy Hatcher

"In first grade, I lost my self-esteem.
I was a shy, cheerful little girl who was labeled stupid by the teachers and other children.
I was dyslexic, but back then no one knew what was wrong with me."

"From the time I was a teenager, I wanted to become a nurse,
but my problem with reading kept me from trying.
I took a chance in my fifties and was disappointed that it still didn't work for me.
But what I found was even better. I didn't need a degree to make a difference.
I am now a companion to people recovering from strokes
and have never been more fulfilled."

"For years, it was easy for me to tell a lie.
My big sister blamed me for something she did and got away with it.
It's funny how quickly children learn. Now, I never even tell white lies.
If you are honest, your life is simple and you have a lot less to remember."

"I adored the generation that came after mine.
My generation didn't want to rock the boat, and it kept a lot of secrets."

"I am maturing.
When my husband says something dumb, I don't react immediately.
I mull it over, think of his point of view, then let him know why he is wrong."

"PIPPI LONGSTOCKING" . . . ALL GROWN UP. DOROTHY, WITH HER EVER SO SLIGHT SOUTHERN DRAWL, IS A CHARMING SELF-ACKNOWLEDGED LATE BLOOMER. ONCE A COMPUTER SCIENCE MAJOR, SHE FOUND HERSELF ON A ROCKY ROAD WITH THE WRONG COMPASS IN HER HAND LOOKING FOR SELF-ESTEEM. SHE STOPPED DRINKING AND SOUGHT THERAPY. GETTING IN TOUCH WITH HER FEELINGS CHANGED HER LIFE AND GAVE HER MARRIAGE OF FORTY YEARS A LOVE LIFT. DOROTHY IS THE MOTHER OF TWO, GRANDMOTHER OF TWO AND AN AVID ATHLETE WHO IS PASSIONATE ABOUT TAI CHI, HIKING, AND BACKPACKING. BORN IN SOUTH CAROLINA, SHE ALSO LIVED IN CALIFORNIA AND VIENNA, AUSTRIA, BEFORE MOVING TO SANTA FE, NEW MEXICO. DOROTHY IS SIXTY-FIVE YEARS OLD.

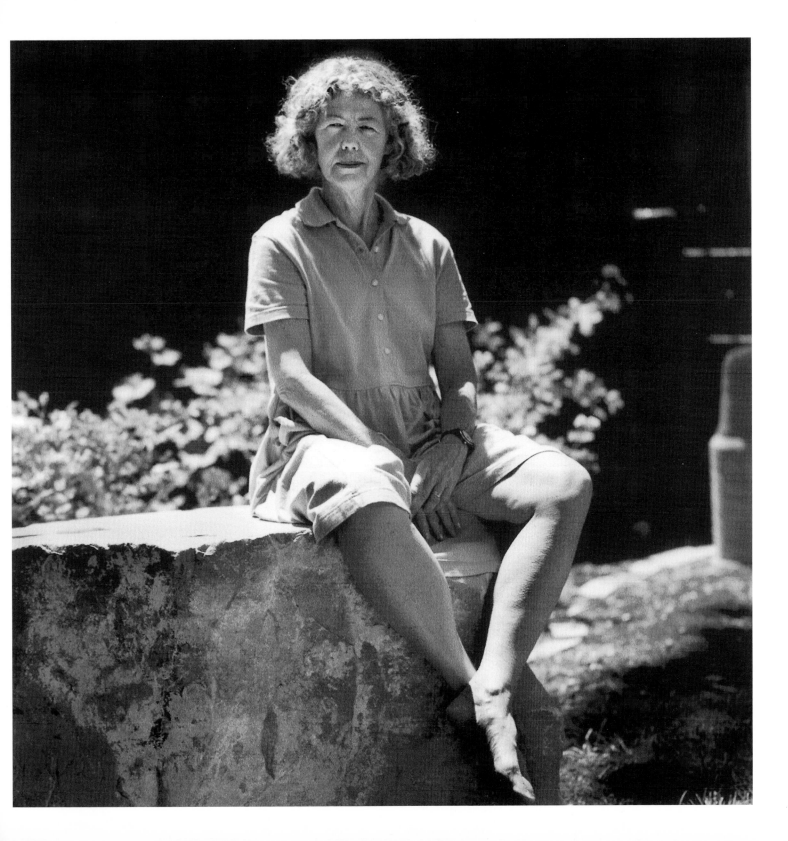

Priscilla Payne

"I am an oil girl from Texas without the oil.
And I had more maturity at fifteen than I did at fifty."

"After thirty years of marriage,
I overheard my husband saying to his friend that he had made me submissive.
He wouldn't even give me recognition for doing that to myself.
He was taking credit for the only decision I felt was mine. I left."

"My advice to young women is to get an education,
so if you need independence you can have it.
And if Prince Charming rides into your life,
make sure the slipper fits before you ride off on that horse."

"I'm from the old school.
I never would have sex with a man I wasn't married to.
I've made more than my share of mistakes.
And for a long time couldn't live without a man in my life.
I believe that I kept looking for that magic
of first infatuation to continue on. It never does."

"I know it sounds crazy,
but I would marry number eight
if I was sure the right one had finally come along."

THANKS TO HER UPBEAT PERSONALITY, PRISCILLA HAS EARNED A PH.D. IN ATTRACTING MEN. WHOEVER COINED THE PHRASE "COCKEYED OPTIMIST" HAD TO BE THINKING OF HER. MARRIED AT FIFTEEN, SHE STAYED MARRIED FOR THIRTY YEARS. SINCE THEN, SHE HAS BEEN MARRIED SIX TIMES. PRISCILLA RUNS THE ART GALLERY THAT HER SON OWNS, AND WHEN SHE IS NOT SELLING A PIECE OF ART OR DOING THE PAPERWORK, SHE KEEPS HER EYES OPEN FOR A STURDY HORSE CARRYING THE RIGHT RIDER. PRISCILLA HAS THREE CHILDREN AND TEN GRANDCHILDREN. SHE IS SIXTY-TWO YEARS OLD AND LIVES IN NEW MEXICO.

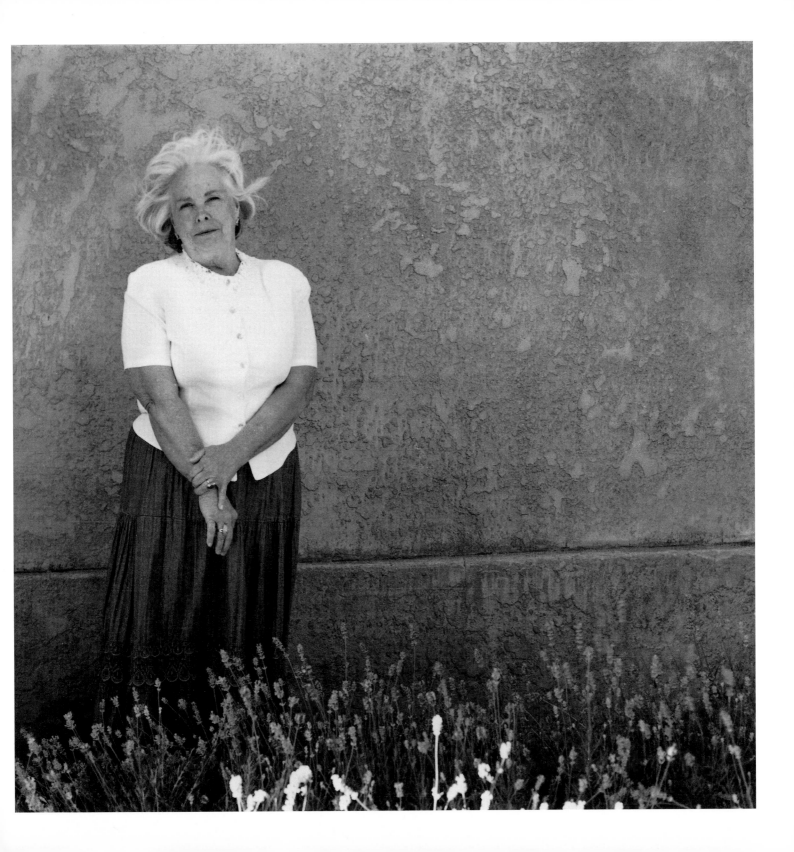

Betty Handschumacher

"At twelve years old, I ran away from home with two dollars in my pocket.
I found a horse ranch and told the owner that I was an accomplished rider.
He put me on a horse that took off, hell-bent on jumping a fence.
I grabbed onto the mane and made it over, trembling but not thrown.
That was my first ride ever, and that's how I've lived my life."

"After thirty-two years of what I considered a good marriage, my husband left me for a younger woman.
I was shattered and in disbelief at the betrayal of unquestioned trust.
Many nights I cried into my pillow, not believing I had the courage to go on.
Eventually, with the help of family and friends, my heartbreak healed, and my second life began."

"I once left a note on a message bulletin board stating
'fifty-three going on thirty-five—desires adventure.'
After hearing from more neurotics than I care to remember, I sailed off with an old man skipper.
While he was sleeping, I manned the ship through fifteen-foot waves.
With that experience I began the process of gaining back my self-esteem."

"Years later, with all bitterness gone,
I remember all the good times—of which there were many."

BETTY IS A GUTSY ADVENTURER WHO DOUBLE DARES HERSELF TO HAVE FUN. IF MYSTERY AND INTRIGUE ARE PART OF CLIMBING THE FORBIDDEN TREE,
BETTY WILL BE SWINGING FROM THE BRANCHES. A SCULPTOR WITH A DEGREE IN PHYSICAL EDUCATION, SHE HAS TWO SONS AND TWO GRANDCHILDREN.
AS A YOUNG WOMAN, SHE STARTED A NURSERY SCHOOL IN A CHURCH BASEMENT AND RENOVATED A BARN LONG BEFORE IT WAS FASHIONABLE. IN LATER YEARS,
BETTY HAS TRAVELED ALL OVER THE WORLD—WORKING IN A MISSION HOSPITAL IN KENYA, CULLING COINS IN PARIS, COLLECTING BEETLE EGGS IN PROVENCE
AND SEARCHING FOR ANTIQUE SILVER BEADS IN BALI. BORN IN PENNSYLVANIA, SHE HAS LIVED IN BOSTON, CONNECTICUT, PARIS, AND LONDON. SAILING IS A
PASSION, AND SHE HAS FOUND THE PERFECT SPOT—THE HOME SHE DESIGNED FOR HERSELF IN THE VIRGIN ISLANDS. SHE RENTS IT OUT
PERIODICALLY SO SHE CAN ENJOY THAT WHICH SHE LOVES BEST—PETITE ADVENTURES TO EXOTIC DESTINATIONS. BETTY IS EIGHTY YEARS OLD.

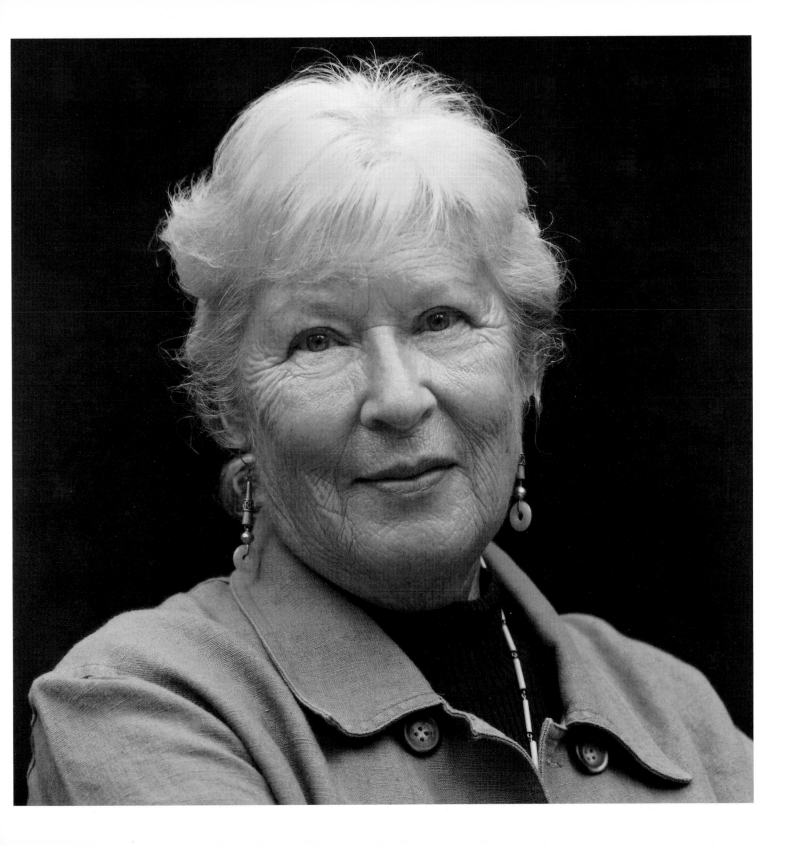

Katie Lee

"Little girl things were foreign to me. I didn't play with dolls.
I was hunting quail and rabbits so my family could eat meat during World War II."

"I didn't want to be in the kitchen. I didn't want to be in the house.
I know men better than most women, and I respect them.
They are less devious, no beating around the bush."

"Passion is what counts in life.
If it's a passion for despising something, so much the better.
But do something about it. Talk is cheap. Actions count."

"I am a lovin' lady, though I try hard to disguise it, which is why a lot of people don't call me a 'lady.'"

"I have never wanted to be a man, but God knows I love them.
I was always one of the boys. I didn't want to be in a woman's world."

"You bet I'm pissed watching this society.
We're on our way out if our government doesn't change. We will be going to hell in a hand basket
unless the powers that be wake up and start paying attention."

"I will fight to my death to stop the scientific destruction of this earth.
Look at what is happening, kids killing each other, cancer, AIDS, Viagra . . . men can't get it up,
and women are getting lumps cut out. Mother Nature is angrier than I am."

STARK NAKED, EXCEPT FOR SOCKS AND A HELMET, KATIE, IN HER SEVENTIES, RODE HER BICYCLE DOWN THE MAIN STREET OF TOWN.
ON THE SPUR OF THE MOMENT, SHE DECIDED SHE WANTED TO GIVE THE LOCAL FOLKS SOMETHING TO LAUGH ABOUT. A FOLK SINGER, EXPLORER, RIVER GUIDE,
AND RACONTEUR, SHE IS A WOMAN TO BE RECKONED WITH. KATIE HAS THE VOICE OF AN ANGEL AND CONTINUES TO SING IN CLUBS AND GIVE LECTURES
ON HER GREATEST PASSION—THE ELIMINATION OF THE GLEN CANYON DAM ON THE COLORADO RIVER. WITH ONLY HER BACKPACK AND DESIRE FOR
ADVENTURE, SHE HAS TRAVELED ALL OVER THE WORLD. DIVORCED TWICE, SHE IS THE MOTHER OF ONE. GIVING UP THE GLITZ AND GLAMOUR OF HOLLYWOOD
AS A YOUNG WOMAN WAS EASY FOR HER, AS SHE PREFERRED THE BEAUTY AND FREEDOM OF THE GREAT OUTDOORS. TODAY, SHE LIVES IN JEROME, ARIZONA WITH
A YOUNGER MAN WHO CONSIDERS HIMSELF TO BE ONE LUCKY FELLOW. KATIE IS EIGHTY-THREE YEARS OLD.

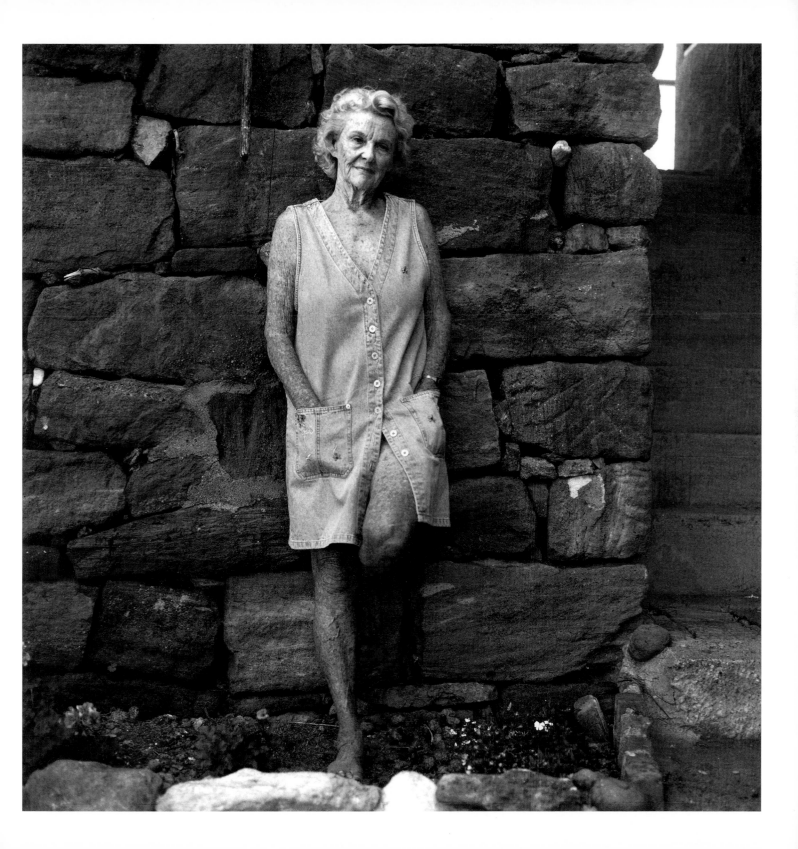

Adela Roatcap

"There was a lot of pain in the house in which I grew up.
My mother had survived the Russian Revolution and a displaced-persons camp in China.
She lived for her piano, and our house was full of music.
I knew how she felt by what and how she played, but we seldom spoke.
By the time I was seven years old, I was reading *Madame Bovary* and *Crime and Punishment*."

"Everyone is shown the 'casting couch' at least once in their life.
It's what you do about it that gives you integrity or a lack of self-esteem."

"Who knows what the truth is?
If we went around telling the whole truth, we would have no friends.
The trick is to clothe the truth in wise and gentle innuendo
and let others discover themselves in what we say."

"I recently lost my youngest daughter, a gifted musician and composer.
She lost her battle with lupus. How does a mother survive?
I know her soul is within me, and I see the world with her eyes."

"Depression can be a good thing if it causes you to change direction."

"Life is terribly unfair.
Just when you have learned all the lessons, you are too old to be taken seriously."

When Adela speaks, you can hear a pin drop in the room. Her gregarious personality turns a mundane art lecture into magic. Over the past eighteen years, she has garnered a loyal following at the University of San Francisco where she celebrates the lives of creative artists, whom she presents as the real heroes and heroines of civilization. Born in New York City, she grew up in Argentina, was married to a career U.S. Navy man and was widowed during the Korean War. At twenty-four, she learned to drive, moved to California, and brought up her three children while acquiring three degrees—including a doctorate from Stanford University. An enormously talented poet, Adela is as ageless as Zeus.

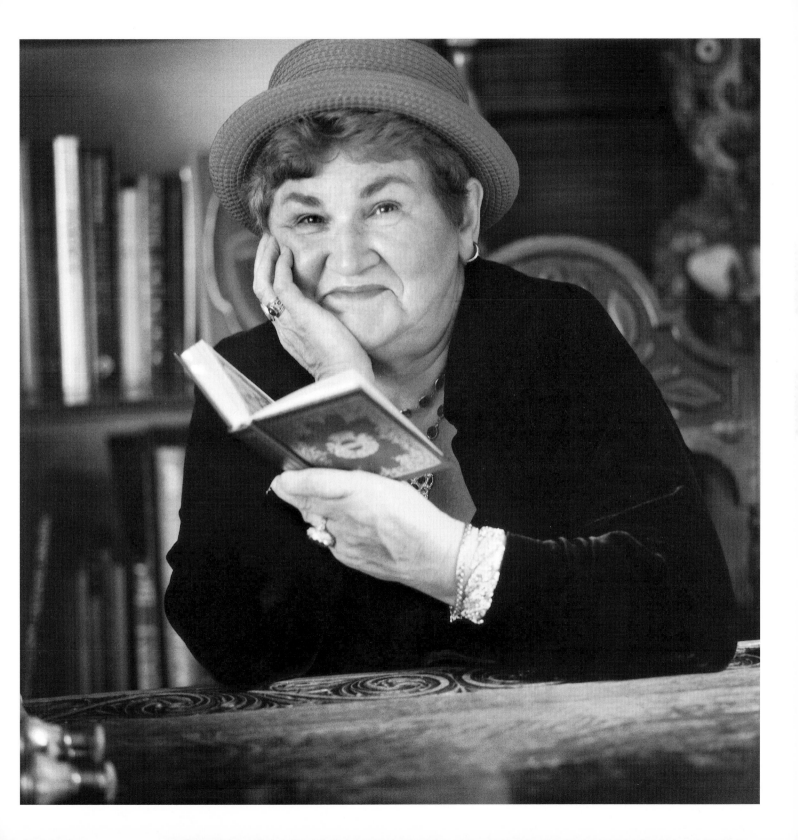

Charlotte Ewing

"I was taught to be a quiet person.
In my day, little girls were seen and not heard.
I was encouraged to keep a circle of respect around me that no one could penetrate.
Unfortunately, I carried that lesson for most of my life."

"My marriage was a dysfunctional disaster.
For years I didn't grow or change.
I spent all my time covering up and lying for my alcoholic husband.
His shame became my shame, and that was the real shame."

"Going back to school saved my sanity.
It was either drugs or education.
I felt that a sound mind, instead of medication to get a sound mind, was the answer.
Until then I was not aware of women's issues.
I was so numb I didn't know what a feeling was."

"If a crystal ball could have warned me of the ups and downs that were in store for me,
I would not have had the strength to understand the wisdom
that I have gained from the ride that was forced upon me."

"Today if I don't like someone or what they are doing, they will know it."

SHE HAS GONE FULL CIRCLE AROUND THE TRACK . . . AND BACK AGAIN. CHARLOTTE IS AN EXERCISE NUT. A DAY WITHOUT SWEAT IS ONE YOU MIGHT AS WELL FORGET. AN EXTREMELY THOUGHTFUL AND INTERESTING PERSON, SHE WAS ONCE A POSTAL WORKER AND WENT BACK TO SCHOOL AT AGE FIFTY-NINE. SHE EARNED HER DEGREE IN SOCIOLOGY AND HAS APPLIED IT BY WORKING WITH WOMEN'S GROUPS. A MOTHER OF TWO AND GRANDMOTHER OF ONE, SHE IS BUSY WRITING A BIOGRAPHY OF HER GRANDFATHER WHO WAS A WELL-KNOWN AND RESPECTED CAVALRY OFFICER AT YOSEMITE NATIONAL PARK. CHARLOTTE IS SEVENTY-FIVE YEARS OLD AND LIVES IN MARIPOSA, CALIFORNIA. SHE IS RECENTLY SEPARATED.

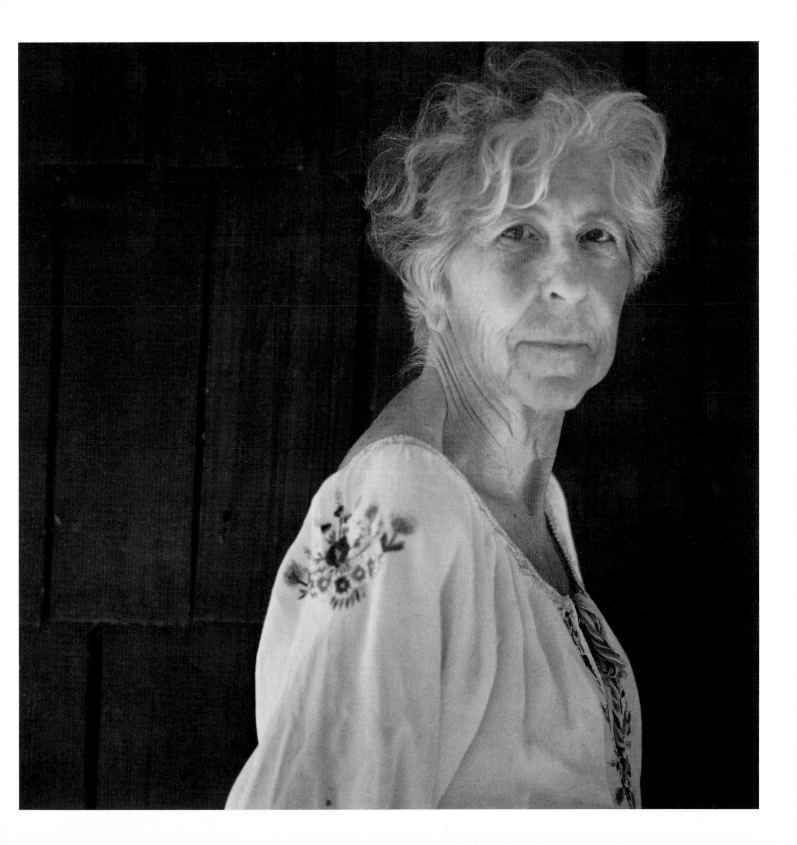

Eugenia Everett

"About twelve years old, I had a revelation that has become my religion.
I realized that I wasn't alone and that I was part of this earth.
My relationship with 'what is' is deeply personal and is not part of any doctrine."

"My father was a chauvinist. A woman's sole purpose was to support a man.
I watched my mother and found out how I would not be treated."

"Barbie dolls are one of the worst things that have been done to women.
We used to put baby dolls in the arms of little girls so they would learn to nurture.
Today, they have eating disorders and are sexually active long before they are ready."

"There are two things that are important in life.
The first is to have love. And I don't care if it's the love of a puppy dog or a person.
And the second is to feel purpose, a reason for being."

"I'm a bag of skin with a lot of emotion inside.
I've never tried to appear any way other than what I am.
Life used to be very serious, not as loose as today. People were poised, posed, and perfect.
It's ironic that without clear social rules, life today is more difficult."

WHILE HER FEET ARE PLANTED FIRMLY ON THE GROUND, SHE IS SOMEWHERE NEAR HEAVEN AS SHE CREATES THE MODERN BRONZE SCULPTURES SHE IS FAMOUS FOR. OUT OF TIME AND SPACE, EUGENIA SEEMS TIMELESS. SHE COULD EASILY BE MISTAKEN FOR A CHARACTER WALKING DOWN THE STREET IN A CHARLES DICKENS NOVEL. SHE POSSESSES A SWEET VULNERABILITY THAT MAKES HER LOVED BY HER MANY STUDENTS. EVERY DAY IN HER HOME STUDIO, SHE TEACHES BOTH ADULTS AND CHILDREN TO COLOR OUTSIDE THE LINES. A WIDOW WHO WAS MARRIED FOR FORTY-TWO YEARS, SHE PUT HER OWN CAREER ON THE BACK BURNER TO HELP HER HUSBAND RUN A RESORT FOR THIRTY YEARS. WITH NO REGRETS, SHE IS NOW ENJOYING HER OWN TIME. EUGENIA HAS TWO CHILDREN, FIVE GRANDCHILDREN, AND IS NINETY-FOUR YEARS OLD. SHE LIVES IN SEDONA, ARIZONA.

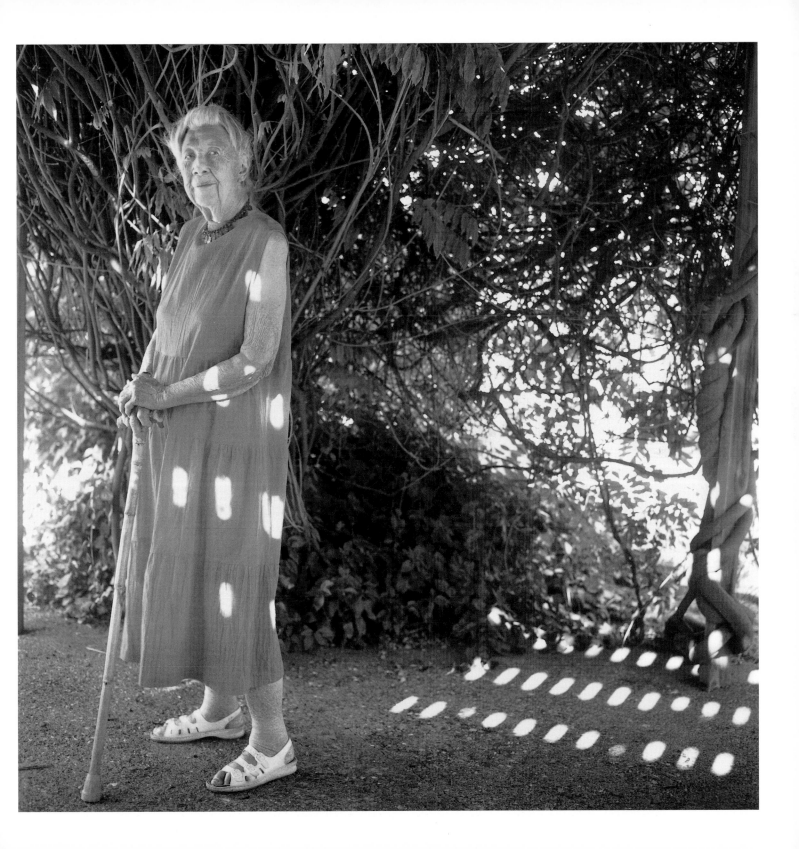

Clara Gaines

"As the child of a minister, I moved around a lot. It didn't bother me at all.
I never minded leaving any place because meeting new people excited me."

"It's funny how your own life can be a surprise.
By my age, I would have expected to know all there is to know about myself, but I was wrong.
I didn't know that I would enjoy a musical instrument or that I would be good at it.
And I suppose that is because I never tried it."

"I'm now old enough to be optimistic about being a pessimist.
Having done so many things, so many times,
a challenge of getting older is to maintain enthusiasm."

"New Year's resolutions have never worked for me.
But I once made a life decision that was, I suppose, a resolution.
I decided that every day I would do something good.
Some days it's as little as picking up a paper in the street."

"I have had a wonderful life, and I wouldn't change anything—but for some reason,
I wouldn't want to live it over again."

A MINISTER'S DAUGHTER AND A COACH'S WIFE, CLARA IS A MOVER AND SHAKER. BORN IN WEST VIRGINIA, SHE LIVED IN PITTSBURGH, ANNAPOLIS, AND ROANOKE, VIRGINIA, BEFORE MOVING TO WINSTON-SALEM, NORTH CAROLINA. SHE HAS A MASTER'S DEGREE FROM COLUMBIA, A HUSBAND OF FIFTY-ONE YEARS, TWO CHILDREN, AND FOUR GRANDCHILDREN. CLARA HAS BEEN BOTH A GUIDANCE COUNSELOR AND GUIDANCE DIRECTOR. KEEPING BUSY IS NOT A CHALLENGE. SHE WORKS OUT EVERY DAY AND IS ACTIVE IN THE LINKS, A BLACK WOMEN'S ORGANIZATION THAT WORKS MIRACLES IN MANY COMMUNITIES. WITH HER HUSBAND BY HER SIDE, SHE RUNS THE LOCAL BRANCH OF MEALS ON WHEELS AND, IN HER SPARE TIME, PLAYS HAND BELLS IN THE CHURCH CHOIR. CLARA IS SEVENTY-TWO YEARS OLD.

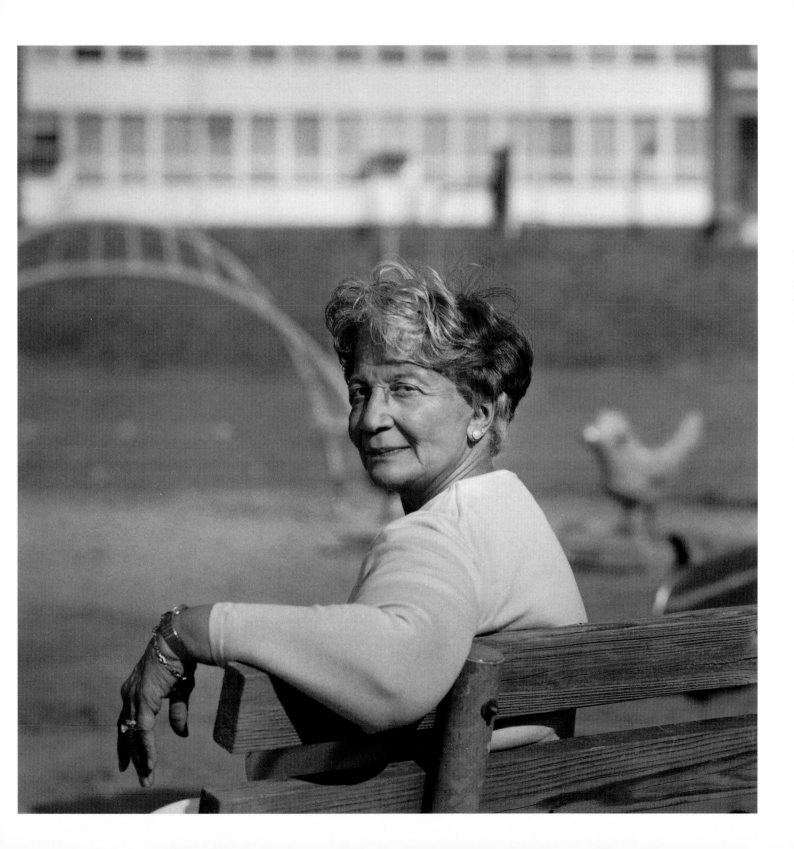

Mary Lyon

"I was a little squirt, who was home taught until I was twelve.
I was also schooled by my parents not to be prejudiced against anyone.
That was a lesson I learned well."

"I like routine.
Living in a good rut is fine for me. I like my own company.
I don't have a vast social life, and I don't require a lot of stimulation,
but what is important to me is place. I have to be happy in my environment."

"I found out a secret when I worked in education for many years.
Very often the people who have the most degrees need them."

"I never married.
The ones that I wanted didn't want me.
The ones that wanted me, I wouldn't have."

"I don't like the feeling of being hampered.
I like the fact I can do anything I want. All my options are open.
I don't have to answer to anyone but myself."

BORN IN KANSAS CITY, MARY HAS ALWAYS HAS ALWAYS BEEN INDEPENDENT AND IN CHARGE. WITHOUT HER AT THE HELM,
THE HOMELESS SHELTER THAT SHE PRACTICALLY RUNS BY HERSELF WOULD BE IN TROUBLE. FOR MANY YEARS, SHE WORKED AS ASSISTANT
TO THE DEAN AT THE UNIVERSITY OF CALIFORNIA. FROM RUNNING A SOUP KITCHEN TO MONITORING THE BAKE SALE AT HER LOCAL CHURCH,
MARY HAS ALWAYS BEEN A PERSON TO HELP THE UNFORTUNATE. HAPPY AS A LARK, SHE CAN BE SEEN ZIPPING AROUND TOWN IN THE RED
SPORTS CAR SHE CALLS HER "HOT ROD." SHE IS EIGHTY-SEVEN YEARS OLD AND LIVES IN SANTA FE, NEW MEXICO.

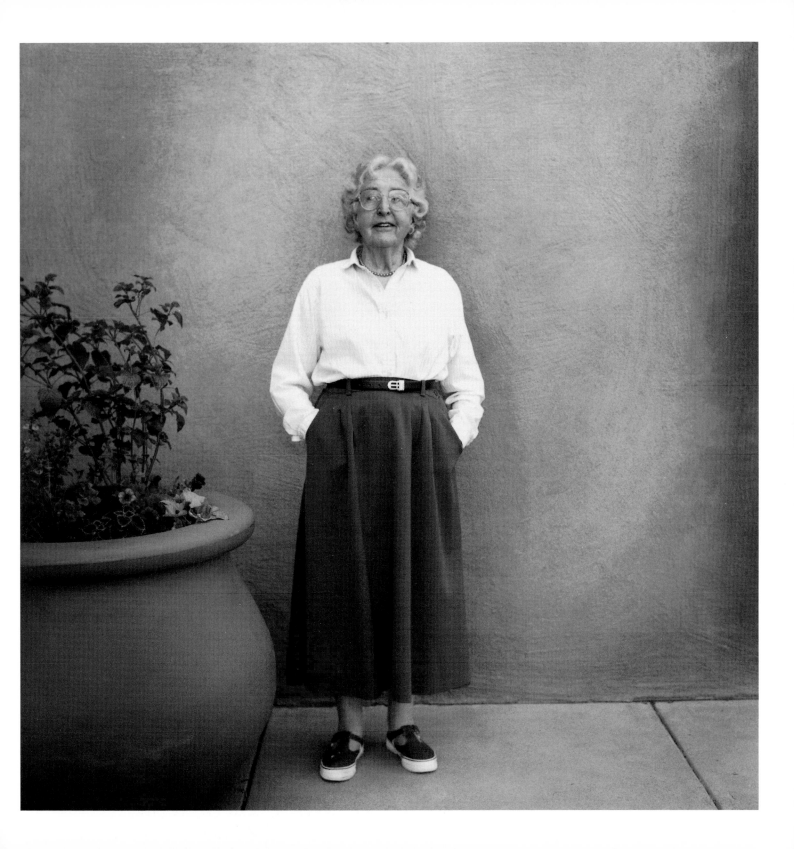

Mercedes Lacroze

"As a youngster I had to try everything.
I would go ice skating, and I wouldn't just be imitating Sonja Henie. I became her."

"My father, a surgeon, who was my hero, was killed in a plane crash when I was sixteen.
We lost everything . . . the house was sold, the land, and the boat.
I learned then that in a second, all of life as I knew it could be over."

"When I was fifty, I thought, well, I have ten more useful years ahead of me;
I felt that I had to hurry up, and that was a useful thing."

"Give me a problem and I am happy.
I love struggle and challenge . . . it is then that I am the most alive.
The adrenaline flows, and I feel like nothing can stop me.
If I don't have a problem, I go out and find one."

"Never have I ever done anything to one hundred percent of my ability.
I stop just short of heaven."

"In my life, I have owned thirty-seven houses.
I would fill them with antiques, make them beautiful, and then sell them.
My possessions owned me. I didn't own them.
What I truly own is my character, the love of my family, and my memories."

"Today, the only house I own is the one I built myself—my family."

MERCEDES IS A THUNDERING TORNADO AND A LAZY SUMMER DAY MIXED TOGETHER. THOUGHTFULLY SPOKEN WORDS MIXED WITH THE DARTING MOVEMENT OF HER EYES CONVEY HER ENORMOUS PERSONALITY. MERCEDES, WHO WAS BORN IN LATIN AMERICA, CANNOT SIT STILL. FOR MANY YEARS SHE RAN AN ANTIQUES BUSINESS, THEN THREE WORLD-CLASS RESTAURANTS WHERE SHE WAS NOT ONLY OWNER, BUT ALSO CHEF. IN HER FIFTIES, SHE TOOK UP GOLF AND HAD A ONE HANDICAP. A WIDOW WHO WAS MARRIED TWENTY-EIGHT YEARS, MERCEDES TOOK CARE OF HER HUSBAND DURING YEARS OF A LONG ILLNESS. SHE HAS FOUR CHILDREN AND FIFTEEN GRANDCHILDREN. TODAY SHE IS STILL GOLFING AND WINNING TOURNAMENTS, ALONG WITH MASTERING THE COMPUTER. MERCEDES IS SEVENTY-FOUR YEARS OLD AND LIVES ON LONG ISLAND, NEW YORK.

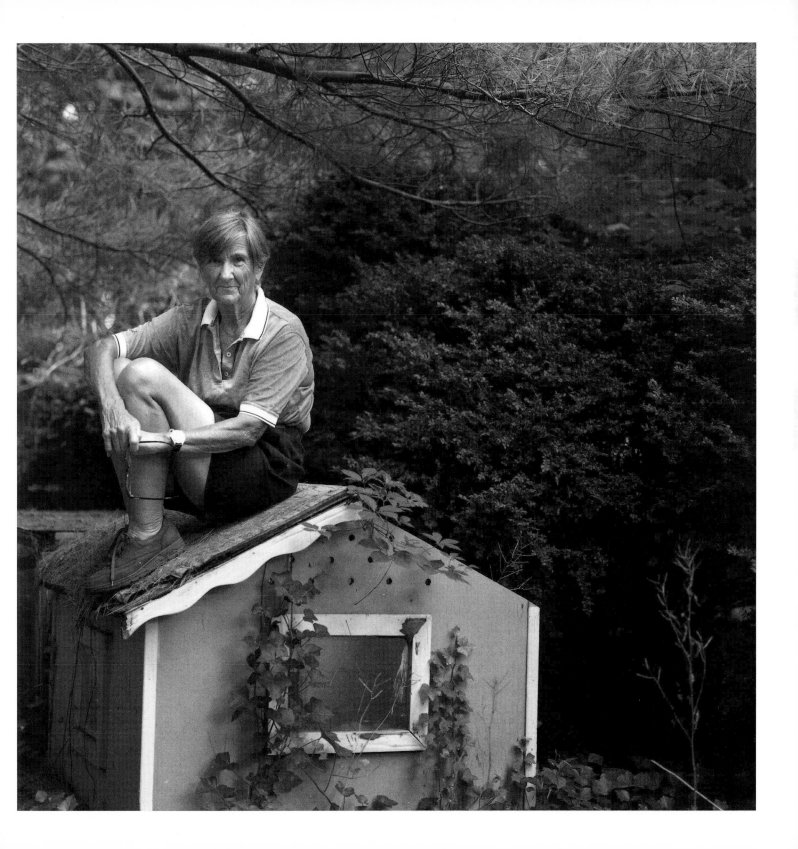

Celeste DiBiase

"I was a Catholic and that was all I knew.
I went to confession after I got married. I was only fourteen years old.
The priest asked questions that were none of his business.
He accused me of using birth control. I said to myself,
you saw me today, but you will see me no more, and that was that."

"Children today are spoiled.
They take food without asking, and think nothing of it. Nobody spoiled me.
I cried enough tears to do the laundry when I was taken out of school."

"After reading the Bible, I decided to change my religion.
My Catholic husband went to my parents and tried to give me back.
My father wanted to kill me. And my mother said she didn't know me.
I stuck to my decision, and I didn't give in.
Eventually my husband found God. And we became missionaries."

"There are two important things in life.
One is to smile, and the other is to pray.
If you pray, you will smile, and that is the truth."

"Everyone should read the Bible just once with an open mind.
If you don't like it, you don't have to read it again."

Celeste's Italian accent is as thick as her tomato sauce. And if she wanted to convert the Pope, he wouldn't stand a chance. Born into a poor family in Italy, her twin brother died before his first birthday. As a young child, she loved learning and even slept with her books. In third grade, she was taken out of school to cook and clean the house while her parents worked the land. Eventually, both she and her husband traveled all over the world as missionaries. Now a widow who was married for fifty years, Celeste is the mother of ten and grandmother of thirty. She spent most of her life cooking and expects to spend the rest of it eating. Celeste is ninety-eight years old and lives in Chatham, New Jersey.

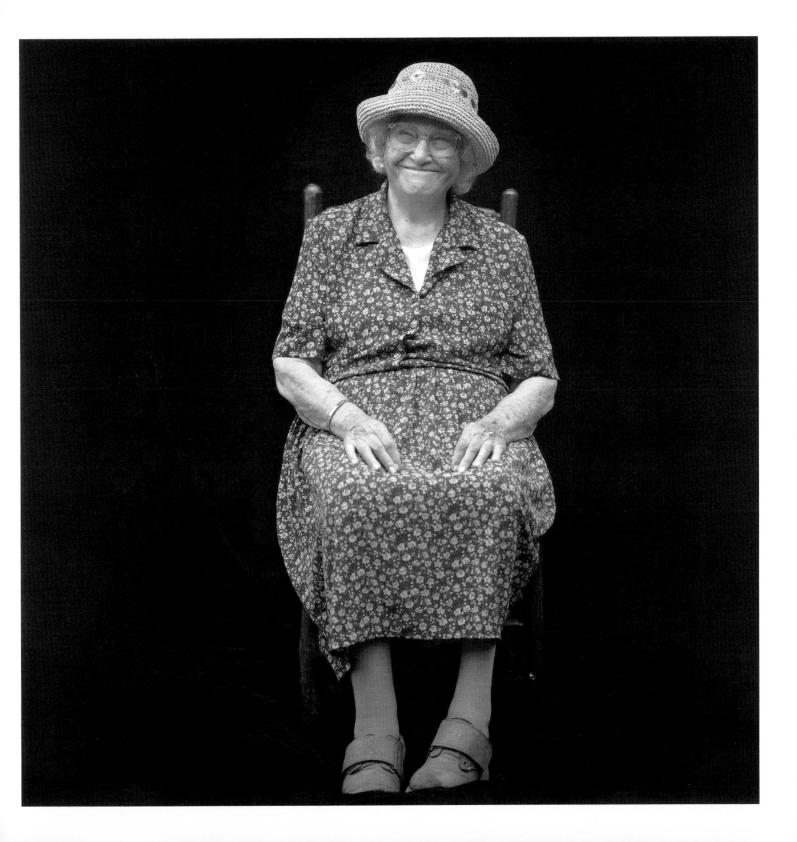

Mariann Loveland

"I was the only child of an alcoholic mother and a Navy officer.
My mother and I followed my father's ship. We moved seven times in one year.
To survive, I created my own private world, a portable reality that moved with me.
I learned early that when I followed my dreams, the universe cooperated."

"When I was younger, I got hurt easily and took the actions of others personally.
Now, if someone says or does something hurtful, I know it's their problem, not mine."

"The day I became a professor, I learned an important lesson about authority figures.
The day before, no one came to me for advice. Suddenly, on my first day of moving into my new position,
I was supposed to be endowed with wisdom.
I was no different from one day to the next. Titles convey power."

"I have never been a conformist. I've been married six times, and none was a mistake except one,
which I got out of quickly. In the others I learned a lot, and they are a major part of who I am today.
I'm not sorry. I'm grateful."

"Tell the truth no matter what.
If you base your life on lies, you're not really there to enjoy it."

IF A FABRIC COULD BE A PERSON, MARIANN WOULD BE VELVET LINED WITH MINK—WARM, SOFT, AND SENSUOUS WITH A RICHNESS THAT HAS NOTHING TO DO WITH MATERIAL WEALTH. SHE IS A STROKE SURVIVOR WHO ALSO WAS HIT BY A CAR AND HAD A NEAR-DEATH EXPERIENCE. ALWAYS SURROUNDED BY CANVASES AND A RAINBOW OF PAINT JARS, HER HOME STUDIO IS FILLED WITH ROMANTICALLY MODERN WORKS OF ART THAT ORIGINATE IN HER IMAGINATION. TODAY SHE GIVES ART WORKSHOPS AT CORNELL UNIVERSITY AND TOURS THE COUNTRY PAINTING MAGNIFICENT MURALS. OVER THE YEARS, MARIANN HAS BEEN INVOLVED WITH THEATRE, BOTH AS AN ACTRESS AND STAGE DESIGNER, WHILE LIVING IN HAWAII, ALASKA, VIRGINIA, AND BOSTON. HAPPILY MARRIED FOR FIFTEEN YEARS, SHE AND HER HUSBAND ARE THE LOVING CARETAKERS OF TWO ENGLISH SPANIELS. MARIANN IS SEVENTY-ONE YEARS OLD AND LIVES IN ITHACA, NEW YORK.

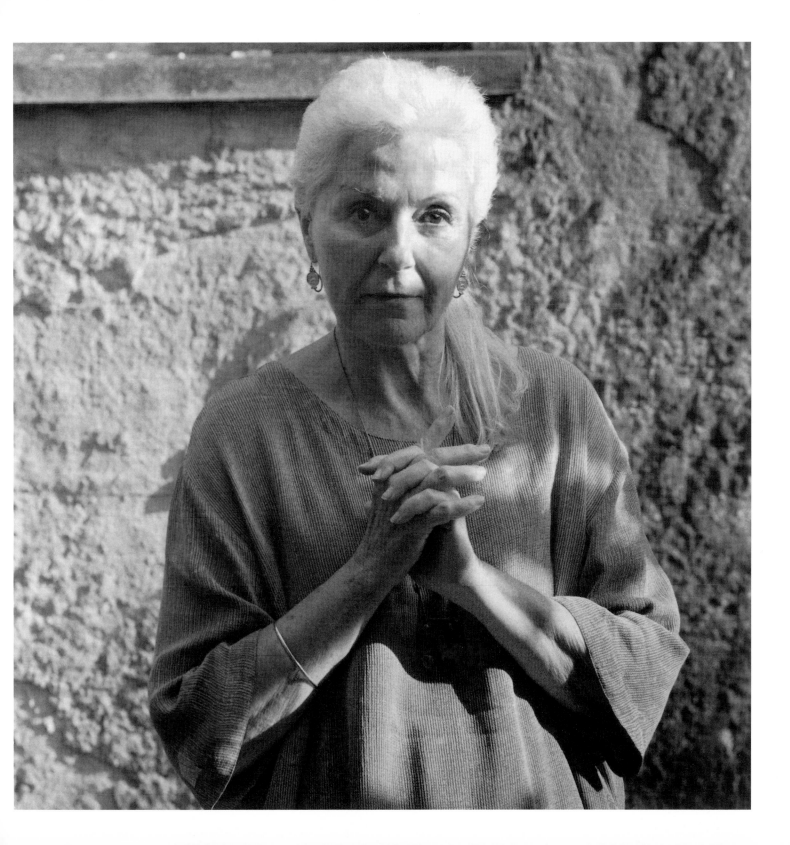

Phyllis Manning

"As an infant, I was the Christ Child in the Christmas pageant,
and I've been showing off ever since."

"I was born into a narrow world and
didn't know or care about other cultures or ways of life.
I stretched myself and found out that all human beings have the same emotions,
and we are much more alike than different."

"When I started belly dancing,
my husband just hoped that I would get well soon, and
my children told their friends that I was an actress.
What I do is an art form not meant to entice, but to entertain.
It also happens to be great exercise."

"I always try new things and do more than I think I can.
So I seldom get bored or depressed."

"The arts don't need a language.
People everywhere don't need an interpreter to look at a painting
to get joy or to see dance and feel happy."

"My advice to mothers is ask your child's opinion and they will feel valued."

BORN A BAPTIST IN THE BIBLE BELT, PHYLLIS IS A RELIGIOUS REPUBLICAN WHO SURE KNOWS HOW TO HAVE A GOOD TIME.
WITH WARMTH AND HUMOR, SHE GOES ABOUT HER BUSINESS OF TEACHING WOMEN THE ART OF EGYPTIAN DANCE. CALLING THEMSELVES
"JEWELS OF THE NILE," THEY DELIVER BELLYGRAMS AND PERFORM MONTHLY. MARRIED FIFTY YEARS, SHE IS THE MOTHER OF THREE AND
GRANDMOTHER OF SIX. WHEN SHE'S NOT JIGGLING UP A STORM, SHE IS ACTIVE IN THE DAUGHTERS OF THE AMERICAN REVOLUTION AND THE
ART AND ORCHESTRA LEAGUES IN OKLAHOMA CITY, WHERE SHE LIVES. PHYLLIS IS SEVENTY-FOUR YEARS OLD.

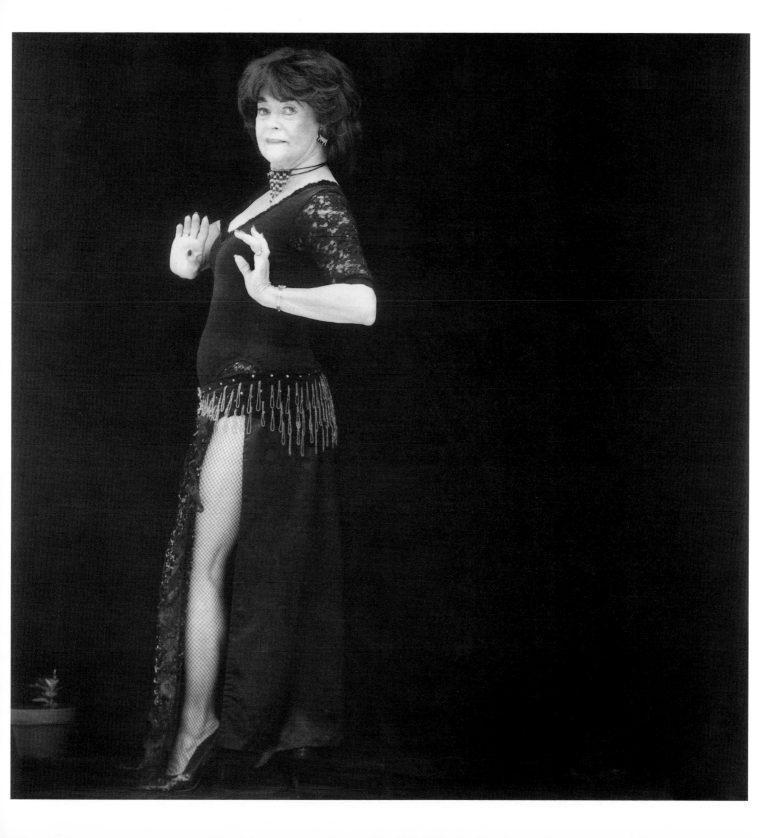

Arline Kneen

"I was an only child in a house that was a revolving door with no locks or keys.
People would come and visit and never leave. My mother had a friend, I called her Auntie Branford,
who came for dinner and stayed twenty years. I've kept up that tradition by having foreign students
stay in my home and doing my best to make everyone feel welcomed."

"The one thing I don't understand is how come, years ago, when we rode in street cars and had to make so
many transfers, we weren't rushing. Everything took so much more time, but we had more time."

"Listening to what people have to say is a skill I've developed.
I learn from everyone all the time. I take that knowledge and apply it to my life."

"I want to know everything. I want to know what makes people tick,
why do the people in India wear such colorful beautiful silk clothes and why do many people in Africa
wear hardly nothing at all. I am simply nosy."

"As a mother, I found out how fragile life is when my son drowned trying to save the life of his best friend."

"I have fought hard to be independent as a woman.
Years ago women were not taken seriously. It's better today but not good enough.
When things don't work out, I try another avenue. And if that doesn't work out, I take another street."

"I want to be an old lady, but I can't seem to find my way there."

THE POPULAR SONG "YOU LIGHT UP MY LIFE" DESCRIBES ARLINE. HER UPBEAT VOICE CONVEYS HER ENORMOUSLY HAPPY DISPOSITION.
SHE IS AN ONLY CHILD WHO GREW UP IN OHIO AND HAS NEVER LIVED ANYWHERE ELSE. AS A YOUNG WOMAN, SHE WAS A PROFESSIONAL BALLROOM DANCER
WHO MARRIED THE CUTEST BOY ON THE BLOCK AND NEVER FELL OUT OF LOVE FOR A MINUTE. AFTER THE DEATH OF HER SON,
SHE STARTED A PROGRAM AT THE Y TO TEACH SAFETY PRECAUTIONS. THE MOTHER OF FOUR AND GRANDMOTHER OF FIVE, SHE ONCE HOSTED A RADIO
SHOW CALLED *Off Your Rocker*, FOR THE OVER FIFTY CROWD. TODAY, HER FREE TIME IS SPENT TRAVELING AND GIVING ADVENTURE TOURS,
WHILE RUNNING THE TRAVEL AGENCY SHE STARTED FORTY YEARS AGO. ARLINE IS EIGHTY-FIVE YEARS OLD AND LIVES IN CLEVELAND.

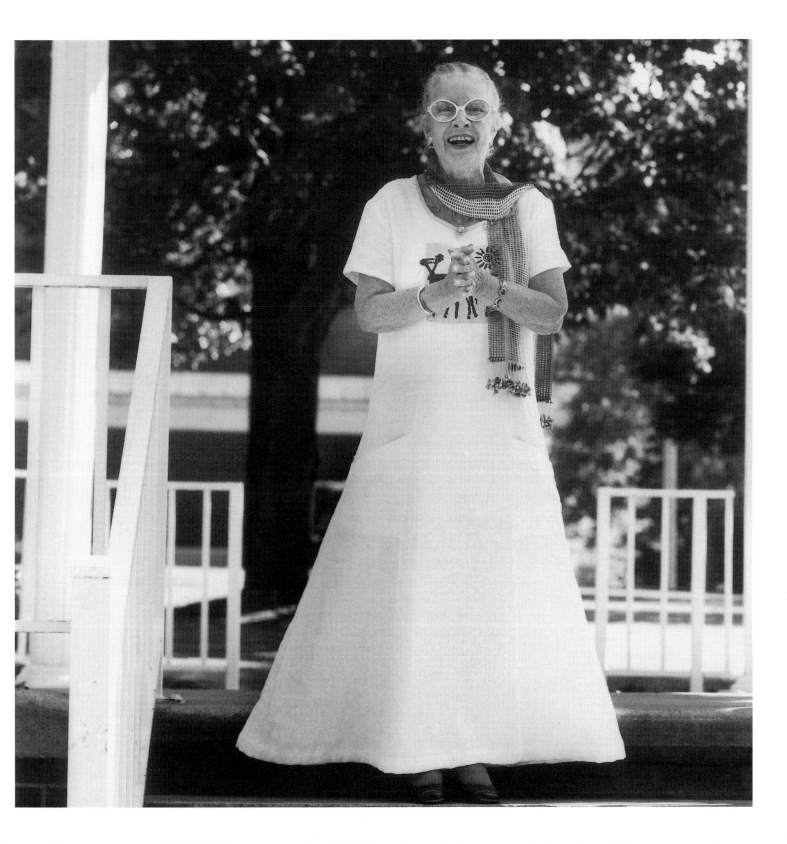

Yoshie Pevehouse

"The mother who raised me was not my biological mother.
I was the child of my father's mistress, a Chinese concubine whom I never met.
After my 'mother' died, I found her diary. I found out how hard it was for her to raise me.
I was heartbroken and still cry when I think of how difficult it must have been for her."

"When I was sixteen, I became engaged against my will.
For three years, I managed to avoid setting a date. It was during that time I fell in love with an American G.I.
On our first date, he took me to see *Cinderella*. I spoke little English, and he spoke very little Japanese.
With our eyes, we fell in love."

"I left my family and my country to follow my heart.
I have gone back to Japan many times, but I have never looked back."

"I grew up in a country where everyone was expected to be the same . . . I broke all the rules.
Today, I see the media being an authority figure to society, and people blindly following like sheep.
People should learn to think for themselves."

"When I hear women saying that they are just a mother I get upset.
I was educated to be a chemist,
but I have found out that to be 'just a mother' is the highest vocation in life."

YOSHIE'S LIFE IS AN EPIC NOVEL THAT COULD BE A MAJOR MOTION PICTURE. TO HAVE HER AS A MOTHER IS TO HAVE ENOUGH LOVE FOR MANY LIFETIMES. BORN IN CHINA, SHE WAS BROUGHT TO JAPAN AS AN INFANT AND GIVEN TO HER FATHER'S FIRST WIFE. SHE ATTENDED THE UNIVERSITY OF TOKYO BEFORE COMING TO THE UNITED STATES AS A BRIDE. MARRIED FOR FORTY-SEVEN YEARS, SHE HAS THREE DAUGHTERS AND FIVE GRANDCHILDREN. YOSHIE HAS SURVIVED THREE MISCARRIAGES, LUNG SURGERY, AND BEING LEGALLY BLIND. THAT DOES NOT STOP HER FROM ENJOYING HER PASSION FOR OPERA, JAZZ AND TRAVEL. EVERY YEAR ON THEIR ANNIVERSARY, YOSHIE AND HER HUSBAND WATCH *Cinderella*. SHE IS SIXTY-EIGHT YEARS OLD AND LIVES IN OLATHE, KANSAS.

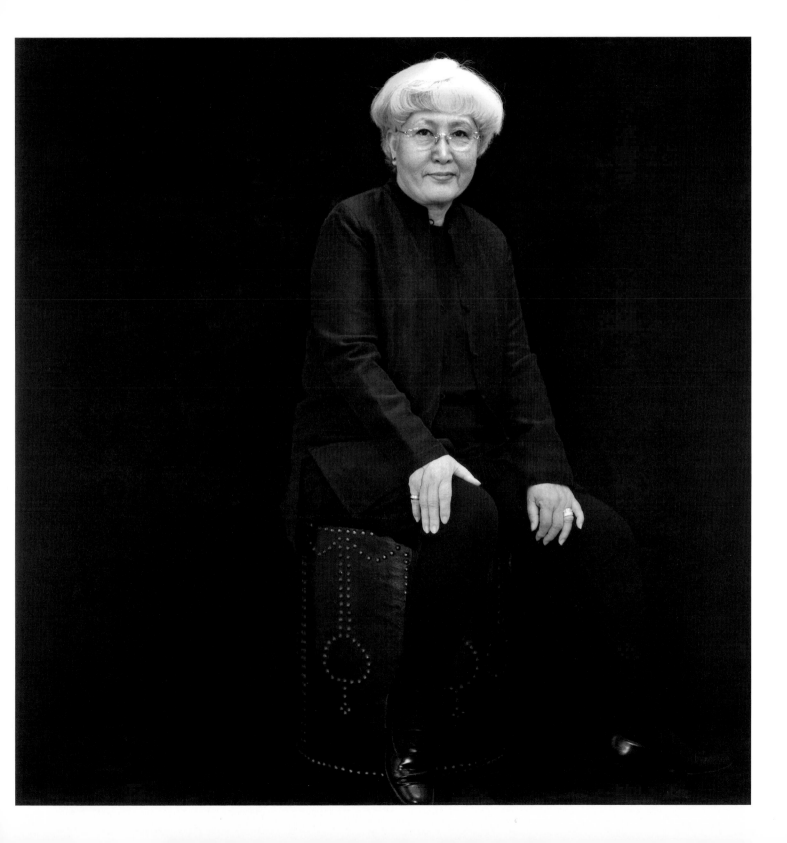

Flora Viale

"My family were nice people but they were snobs.
My father was a big man, a senator in Italy.
People bowed to me, I was royal noble blood, but so uncomfortable in that role.
Then there was the war and we escaped to South America."

"As a little girl, I lived in the garden that was my backyard.
There was a fig tree with two low branches. I made them my chair and swing.
On a small patch of grass, I made potions, mud creams, soup with grass, leaf balls.
It was there that I started creating the work that would become my life."

"As a young woman I was destroyed for many years. I married a doctor who had affairs.
He put me on drugs. My world collapsed. Then he put me into an institution.
The psychiatrist said, 'Yes, you are crazy—for trying to save this marriage.'"

"My heart has been broken many times. I have watched my children make many serious mistakes.
And I've been powerless to stop them.
As a mother, fear is hard to live with. But I have not allowed it to ruin my life."

"I have survived with my spirit intact.
My only regret is that far too often I was not fully in the moment.
I lived in the future, which means I was not entirely in reality."

"Every moment we live there is a possibility of making a memory.
We choose whether it will be good or bad."

LIKE HER WORK, FLORA IS AN ORIGINAL PIECE OF ART. BORN TO ITALIAN PARENTS IN FLORENCE, ITALY, SHE HAS LIVED IN ARGENTINA,
MINNEAPOLIS, TEXAS AND NEW YORK. AS A CHILD ATHLETE, SHE REMEMBERS RACING IN FRONT OF MUSSOLINI. FLORA WAS AN
OPERATING ROOM NURSE WHO RAISED HER THREE CHILDREN ALONE. TODAY SHE TRAVELS THE WORLD GIVING SHOWS OF HER CELEBRITY BUG CREATIONS.
OUT OF NATURAL WOOD, BARK, AND WIRE, SHE CREATES HER OWN MAGNIFICENT INTERPRETATION OF NATURE. WHEN TIME PERMITS, SHE WORKS
WITH HANDICAPPED CHILDREN AND GIVES LECTURES ON CREATIVITY. LIVING ALONE IN A BARN FILLED WITH HER ART,
FLORA ADMITS THAT HER BEST TIMES ARE WHEN HER FIVE GRANDCHILDREN VISIT. SHE IS SEVENTY-ONE YEARS OLD AND LIVES IN POUND RIDGE, NEW YORK.

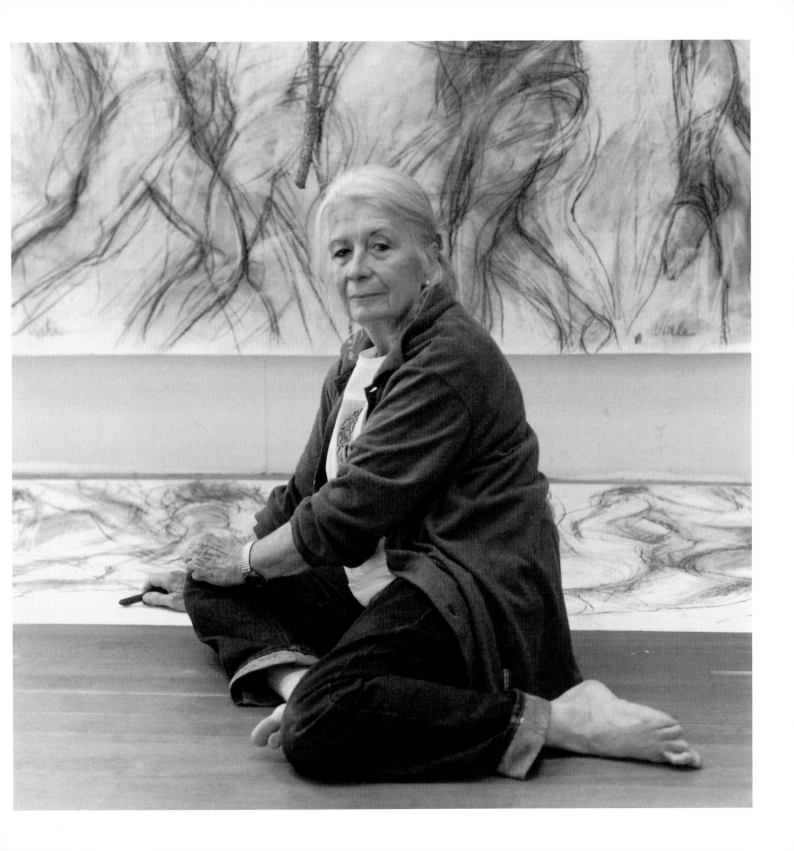

Sister Dennis Eileen

"When I was in high school I had a teacher, Sister Agnes Isabelle. I adored her.
All I wanted to do as a woman was to be like her—the way she stood, the way she held her hands,
the eloquent way she spoke. She was a perfect lady and God used her to bring me to him."

"My life as a nun has been utopia . . . I can't imagine being anything else.
I'm one of the last sisters to still wear the habit, and it's a very important part of my ministry.
It's not a security blanket for me, but I do believe that it brings comfort to many people for what it represents."

"The only two words you need in a prayer are, 'Yes, Jesus.'"

"I like to touch people. I minister to all religions . . . anyone who needs me. I like spontaneous prayer.
Sometimes words are unnecessary. It's wonderful to be with someone when they are getting ready to meet God.
I have the best job on earth."

"Sometimes people who have lost faith are fearful.
I tell them that God has no memory of yesterday if you come to him now, with a heart full of contrition.
I remember once, a man thanked me for giving him a great deal of comfort.
He said I told him God has a lousy memory . . . some people hear exactly what they want to."

"I am vain. I hate the wrinkles on my face.
The good Lord has taken care of that problem by not giving me time to look in the mirror."

With amazing grace from dawn to dusk, Sister Dennis ministers to the sick and prays with the dying. She is a petite bundle of energy whose gentle voice and soothing words give hope to many of the hopeless. Born in Philadelphia, she joined the sisters of Saint Joseph sixty-eight years ago and, for forty-six years, taught advanced high school math. An overly sensitive yet cheerful person, she would not have believed herself suited for the kind of work assigned to her at retirement. Once believing sensitivity a weakness, she found it to be her greatest strength. In the eighties, when AIDS was not understood, Sister started her ministry by holding many in her arms that others would not go near. Recently honored with a doctorate in the humanities, she is a chaplain at Wake Forest University Baptist Hospital in Winston-Salem, North Carolina. She is eighty-five years old.

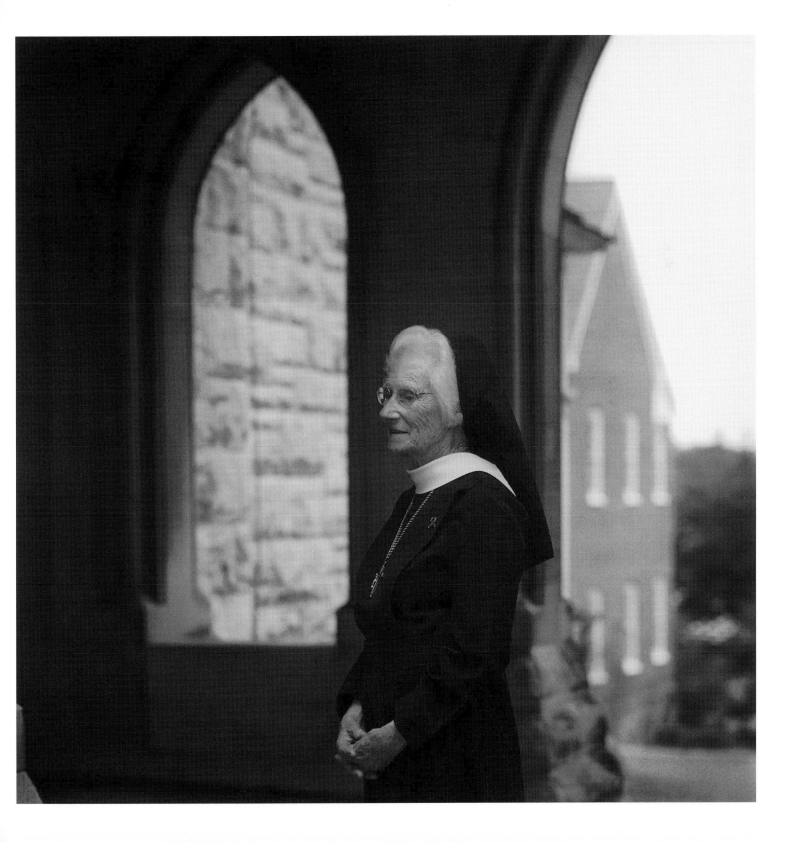

Maggie Williams

"My mother didn't prepare me for reality at all. She was domineering in a mad sort of way.
My job was to practice piano and speak French. She wanted me to be interesting and intellectual.
I was expected to marry an ambassador, instead I became an actress.
Learning to clean dishes, bathrooms, and cook came as a shock to me."

"When my first marriage broke up, I went to Rome. I couldn't bear the stab in my heart when
I would see my husband and his new love. I didn't go because I was particularly adventuresome.
I was being pragmatic since Rome at that time was a less expensive way to live. I had no idea when
I boarded that plane with my two sons that I was going to end up meeting the love of my life."

"Bette Davis was a good friend of mine. She was the complete opposite of a cagey celebrity.
On many a rainy day she would call and say, 'Mag, come over for drinks.' If she sensed hesitation on my
part, she'd say, 'I'll tell you what _____ was like in bed.' Aren't woman friends wonderful?"

"I'm afraid we have lost the art of conversation. People used to work at being entertaining
and interesting. Anyone who speaks incessantly about themselves is simply boring
and people who focus on nothing but money are already bankrupt."

"The real beauty of life lies someplace between the highs and overcoming the lows.
I can be completely happy sitting by myself sipping a good cup of tea in a charming environment."

"My husband's death was a huge blow to me. Some things we never get over . . . we move on in spite of them.
Writing is still a passion and reading my great escape. I can travel the world,
step into another life, and become a voyeur of the best sort."

CITING THAT FATE ALWAYS PUTS HER ON THE FRINGES OF PEOPLE WITH ENORMOUS TALENT, MAGGIE FEELS THAT SHE HAD ALL THE PERKS AND
NONE OF THE ANGUISH OF THE WRITING LIFE. A GOOD FRIEND OF LUCILLE BALL, SHE CREDITS HER LIFE SPENT AS A SCREENWRITER
AND PLAYWRIGHT TO LUCY, WHO HIT HER OVER THE HEAD CONVINCING HER THAT SHE HAD TALENT. MARRIED TWICE, THE SECOND TIME
FOR TWENTY-SIX YEARS, SHE IS NOW A WIDOW WHO HAS TWO SONS AND TWO GRANDSONS. ALONG WITH HER SECOND HUSBAND, SHE WROTE FOR
The Many Loves of Dobie Gillis, Bachelor Father, AND MANY OTHER SITCOMS. AS A PLAYWRIGHT, SHE HAS TRAVELED TO IRELAND, GERMANY, RUSSIA, AND
LATVIA. THE SURPRISE OF HER LIFE HAPPENED A FEW YEARS AGO, WHEN A MALE FRIEND WHO WAS WITHOUT FAMILY LEFT HER HIS CASTLE IN IRELAND.
MAGGIE IS OLD ENOUGH TO KNOW BETTER AND SPENDS HALF THE YEAR IN IRELAND, THE OTHER HALF IN WESTPORT, CONNECTICUT.

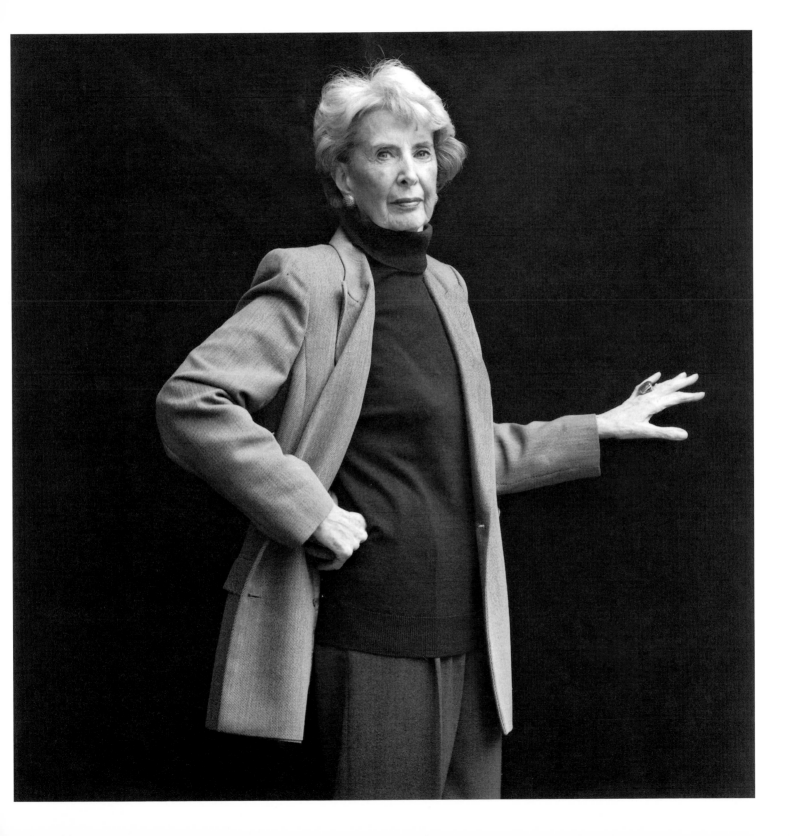

Dudley Shearburn

"During the Depression, I wore shoes with cardboard in them to cover the holes. My grandmother bought
me patent leather slippers with T-straps. My mother thought her mother-in-law was mad as a hatter.
She should have bought oxfords. Well, I treasured those shoes. I stuffed my feet inside them until I had blisters
and couldn't walk. Thank you, Grandma Sis, for knowing when to be extravagant."

"I have no money. I have been desperate but never poor. As a college professor with a large family,
I learned how to fix up, make over, and spot a treasure in a heap of trash. I love junk shops and have learned
how to tell the difference between a silk purse and a sow's ear."

"Having seven children in eleven years forced me to become creative. I can remember putting all five boys in the bathtub
while I served them spaghetti dinner. I did find out that spaghetti in the bathtub drain makes for a slippery marriage."

"My ex-husband was conservative. I am a liberal Yellow Dog Democrat. Philosophically, he lived on the North Pole
while I lived on the South. When I walked away from my handsome, successful businessman-husband,
I decided that I would never allow possessions to control my life.
I had a degree. I grew up in the Depression, and it never for one second occurred to me that I wouldn't make it."

"I never remarried, because why would I stick a bean up my nose twice?
I didn't want anyone telling me what to do with my time, how to spend my money, or how to raise my children.
I have nothing but respect for blended families. I just couldn't do it."

"Today, young women do not understand why we even bother to press the issues of feminism.
They don't see the battle, they only see the results. Why shouldn't they get their boss a cup of coffee?
The truth is they can because they have choices."

DUDLEY HAS A RAGE TO LIVE AND A SPIRIT TO MATCH. NO TELEVISION FOR THIS ENGLISH PROFESSOR, WHO READS FOR DAYS AT A TIME IN HER
INNER-CITY WAREHOUSE LOFT. EACH MORNING BEGINS WITH COFFEE, *The New York Times*, AND HER BEST FRIEND . . . SILENCE. SHE IS A MODERATOR
OF BOOK CLUBS AND WILL DO THINGS SUCH AS READ FRENCH FEMINISM AND THEN TAKE THE CLASS TO PARIS; READ JAMES JOYCE, THEN OFF TO DUBLIN
THEY GO. ALL BY HERSELF, SHE THINKS NOTHING OF HOPPING ON A TRAIN, PLANE, OR WHATEVER ELSE HAPPENS TO BE MOVING. THIS SOUTHERN BELLE OF
THE BALL WAS BORN IN ALABAMA AND RAISED HER FAMILY IN ST. LOUIS. DUDLEY WORKS TIRELESSLY WITH THE ILLITERATE, AND SHE TRAINS TEACHERS
AT SALEM COLLEGE IN NORTH CAROLINA. SHE IS THE MOTHER OF SEVEN, GRANDMOTHER OF SIX, AND IS SEVENTY-FIVE YEARS OLD.

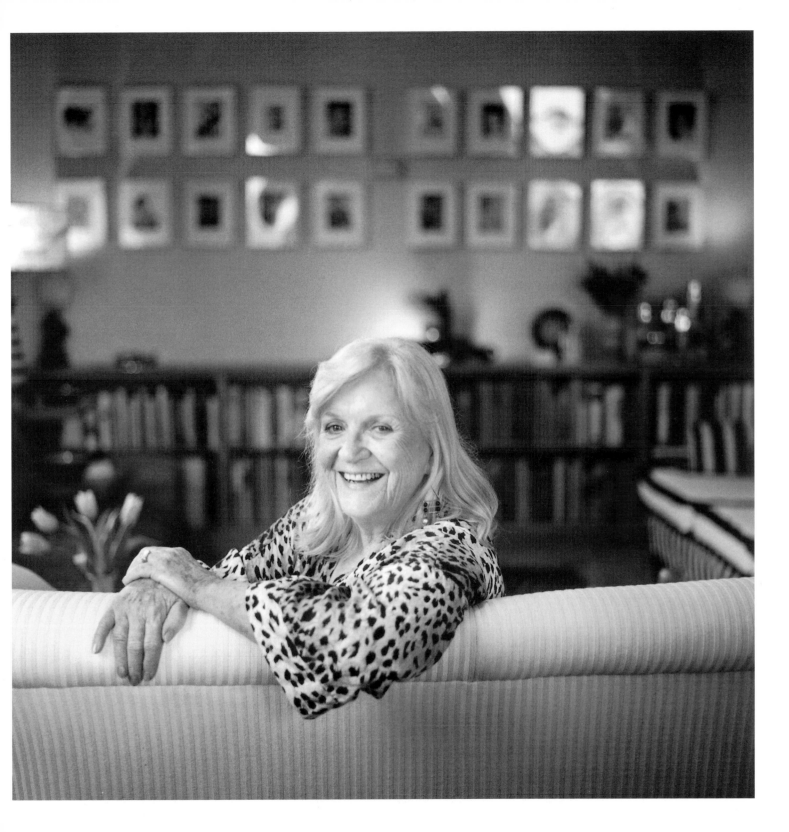

Elizabeth Gaynor

"As a child I was a thinker.
I enjoyed pondering questions without answers, and I still do."

"Life was easier for women when I was a young girl. My generation had a definite set of rules.
We had our white gloves on and marriage as a destination.
Certain things were simply not done, and certain things were expected.
We had fewer choices, which simplified everything."

"I believe in seizing the moment before it's too late. I'm not sorry about anything I have done in life.
But I am sorry for the things I could have done and didn't."

"As I grow older and lose some of my physical ability, I find that what is left is much more precious."

"When I attended my fiftieth college reunion, I noticed something wonderful.
People had mellowed out so much, no longer focusing on ego.
Some had had plastic surgery, and others had let themselves go to pot.
However, what we looked like and what we had achieved wasn't important anymore.
Our shared memories, perhaps slightly flawed, brought such joy."

"There is nothing that makes my day more than to pick up the phone
and hear the voice of an old friend."

THERE IS A QUIET ENERGY THAT FUELS ELIZABETH'S PASSIONS, OF WHICH THERE ARE MANY—PAINTING, SAILING, DANCING, AND RESCUING ANIMALS IN TROUBLE. SHE CAN OFTEN BE FOUND IN HER OWN BACKYARD PILATES STUDIO. SHE WAS BORN IN NEW JERSEY TO PARENTS OF IRISH, GERMAN AND ENGLISH DESCENT. AS A YOUNG WOMAN, SHE WAS A FOURTH-GRADE TEACHER WHO MET HER HUSBAND WHILE MOONLIGHTING AS A LOBSTER TRAPPER. MARRIED FOR FIFTY-THREE YEARS, SHE HAS THREE CHILDREN AND FIVE GRANDCHILDREN. BACK IN THE FIFTIES, WHEN SHE COULDN'T FIND A BALLET SCHOOL FOR HER DAUGHTER, SHE FOUNDED THE CONNECTICUT DANCE SCHOOL, A NONPROFIT ORGANIZATION THAT ENABLES MANY PEOPLE, BOTH YOUNG AND OLD, TO FULFILL THEIR POTENTIAL. HER GREATEST DREAM IS TO MAKE IT TO BASE CAMP AT MOUNT EVEREST. ELIZABETH IS SEVENTY-FOUR YEARS OLD AND LIVES IN SOUTHPORT, CONNECTICUT.

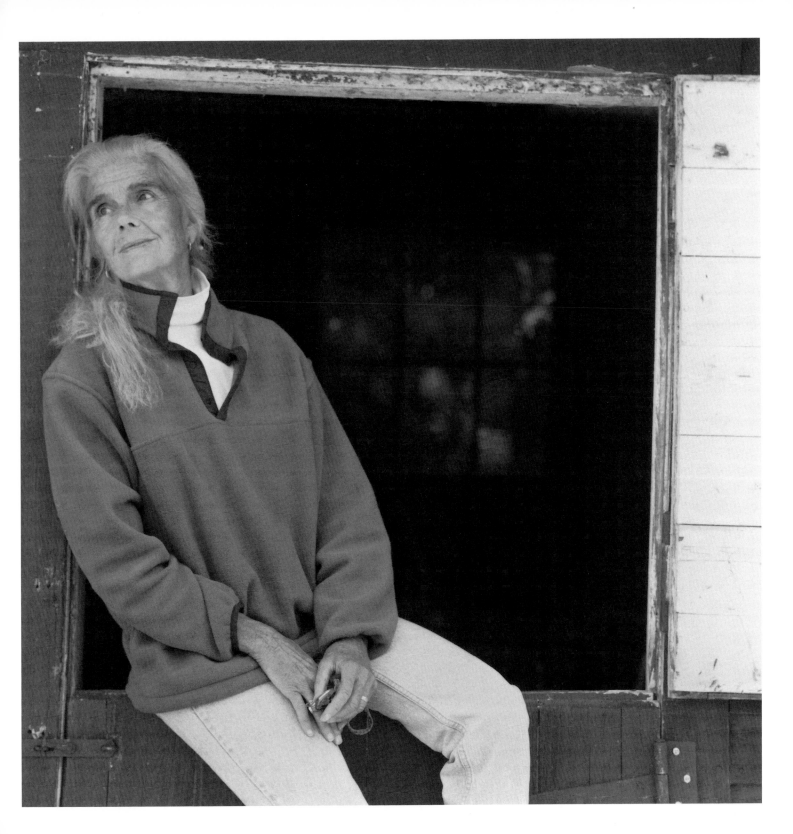

Jane Arthur

"Afraid that I would be snobby, my mother put me down a lot.
I was not allowed to defend myself verbally and learned to keep my mouth shut.
Even though I was a good student, I was terrified to ask questions."

"We had four daughters close together, and then twins.
My husband died of a heart condition, and my brother was murdered in a robbery.
I went to work and didn't allow myself to grieve; nor did I allow my children to.
That is when I started drinking."

"For many years, I felt sorry for myself.
I married again, this time to a funny and adorable alcoholic.
There was never a defining moment.
One day I just woke up and knew I had to stop."

"I stopped being a victim and learned about my many rights:
the right to say I don't care, I don't understand, I don't want to.
I have rejected organized religion.
Being sober is the greatest miracle of my life."

AS A FEMALE CLOWN FOR SEVERAL YEARS, JANE FOUND OUT THAT WITH ALL THE BUREAUCRACY OF THE ORGANIZATION, CLOWNS JUST DON'T HAVE ENOUGH FUN. EVEN THOUGH SHE HAS A DEGREE IN BUSINESS, SHE DECIDED TO GO WITH HER HEART AND BECOME A SUBSTANCE ABUSE COUNSELOR. SHE WEARS THE BADGE OF SUCCEEDING WITH OUTWARD BOUND TWICE. IN HER SPARE TIME, JANE ENJOYS TABLE TENNIS, HAVING BECOME A NATIONAL CHAMPION WHILE IN HER SIXTIES. BORN IN IOWA, SHE NOW LIVES IN A RETIREMENT RESIDENCE IN CHARLOTTE, NORTH CAROLINA, WHERE SHE IS THE HEAD OF THE EVENTS PROGRAM. JANE IS SEVENTY-FIVE YEARS OLD AND HAS NINE GRANDCHILDREN.

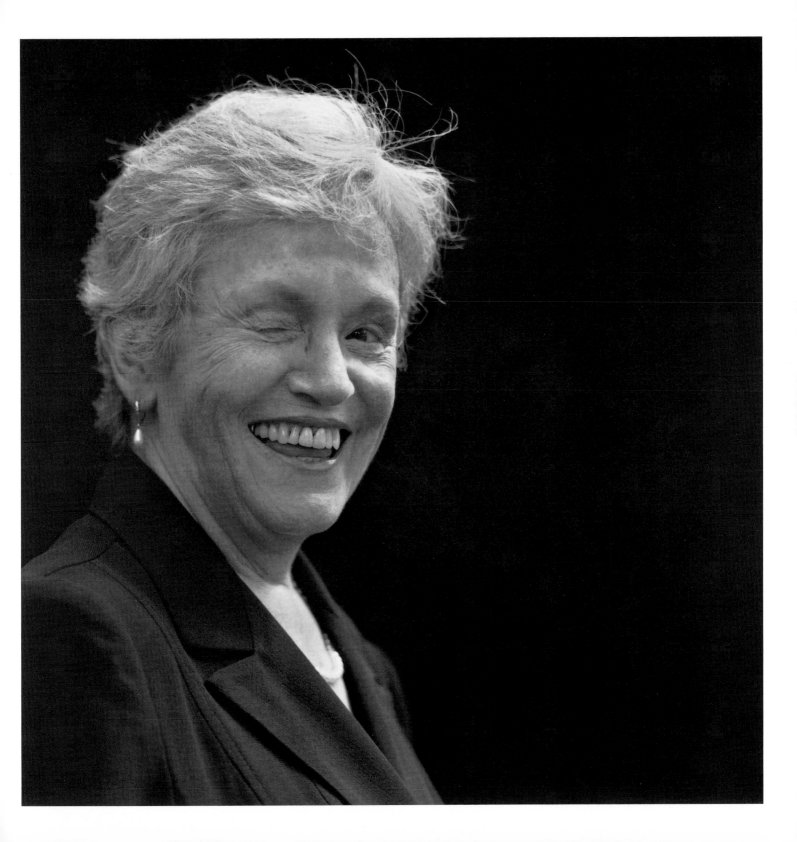

Mary Elizabeth Hill

"My childhood was an innocent time.
I remember there being a scandal in the neighborhood—a certain family
had been seen playing cards.
None of the children who lived on my block were allowed anywhere near that house.
I often wonder what they would say today."

"I have had the most wonderful father, husband, and son any woman could want.
In spite of that, I feel that men are not nearly as interesting as women."

"In all my years of working as a child psychologist,
the happiest little girl I ever met played with empty boxes and slept in a bathtub."

"My philosophy on raising children is have them, love them, and then leave them alone."

"The greatest gift a parent can give is the gift of allowing anticipation."

"I am a spiritual person who is very much at home talking to God.
I am never really alone, because I know that Jesus loves me.
Because of that, I have nothing else to strive for."

Mary is clinically blind, yet her life is filled with light. Living alone in the house she shared with her husband of seventy years, she is sharp, inquisitive, and still active in community affairs. This mother of two, grandmother of two, and great-grandmother of four has degrees in sociology, economics and psychology. One of the first women to work at the YWCA, she went back to school in her fifties to become a child psychologist. Along with her husband, she climbed to the top of every major mountain in the United States and traveled around the world three times while in her sixties. Mary is a fifty-year member of the League of Women Voters and past president of the International League for Peace and Freedom. She would like to live as long as God sees fit but longs to see her husband again. She is one-hundred-six years old and lives in Weston, Connecticut.

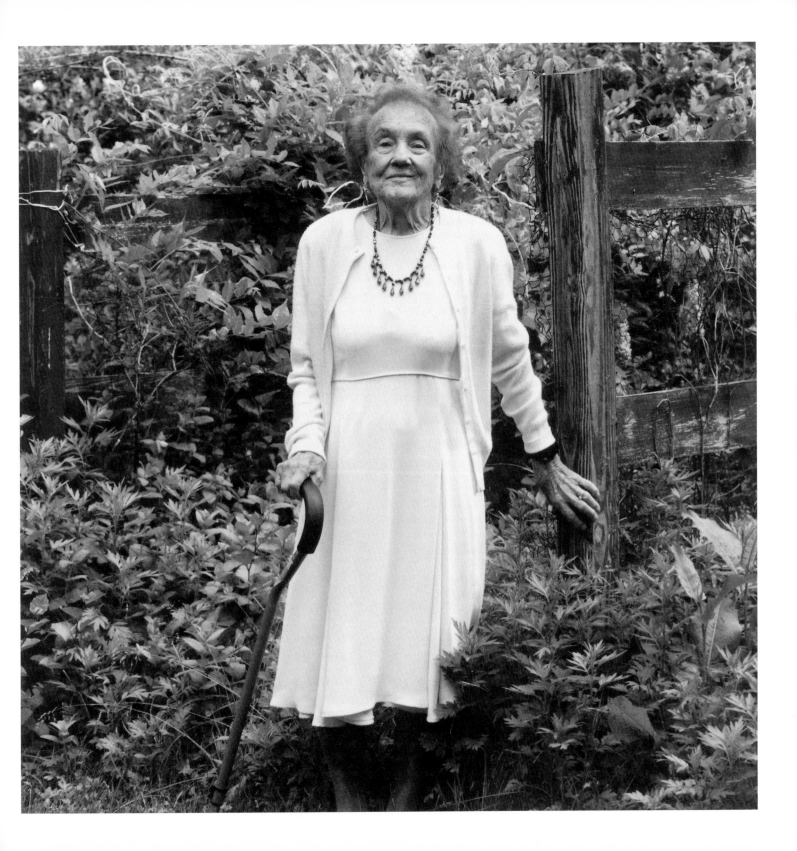

Jane Miller

"Mother taught me early in life to focus on the word *do* rather than *don't*.
When I was nineteen years old, my mother, who had never been near an airplane,
pushed me into the cockpit, yelling, 'Don't fly too low.'"

"If one word could describe me, it would be *gutsy*.
I've lived my entire life being unpredictable.
Maybe because I was born with the name Jane Died,
I've spent my life living it up."

"My husband had great taste in women.
He had affairs with two of my best friends.
I understood that he had a problem and forgave him.
We were married for forty-eight years."

"I have learned to live alone and love it. I do 'outrageous' things.
I blast the music, leave the lights on, and let the water run.
I dance by myself and talk to myself."

A FEARLESS FEMINIST WHOSE OWN DARING VOICE RARELY STEERS HER WRONG, JANE WAS RAISED IN COLORADO WHERE SHE BECAME A GUIDE IN THE ROCKY MOUNTAINS BEFORE BECOMING A PILOT IN THE WAC DURING WORLD WAR II. AFTER EARNING DEGREES IN ENGLISH AND POLITICAL SCIENCE, SHE WENT BACK TO COLLEGE AT FIFTY-FOUR TO BECOME A PSYCHOLOGIST. JANE IS AN AUTHOR AND PANIC DISORDER SPECIALIST. BUSIER THAN EVER IN TODAY'S WORLD, SHE TRAVELS ALL OVER THE COUNTRY GIVING LECTURES. HER LIFE IS DEDICATED TO HELPING PEOPLE OVERCOME FEAR. A WIDOW WHO IS THE MOTHER OF TWO AND GRANDMOTHER OF TWO, SHE HAS LIVED IN ENGLAND, FRANCE, AND AFRICA. JANE MAKES SURE THAT SHE ALWAYS HAS A SECRET INFATUATION TO SPICE UP LIFE. SHE IS EIGHTY YEARS OLD AND LIVES IN HARTFORD, CONNECTICUT.

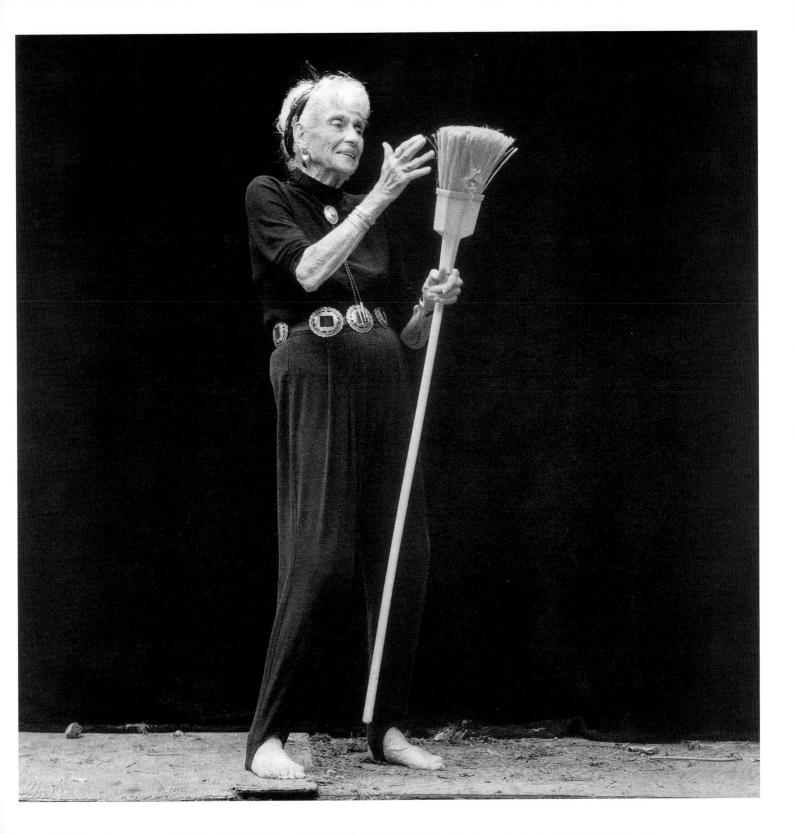

Beulah Mae Winter

"As a young girl, I would sit and watch
my grandmother have her hair brushed by black women she would refer to as slaves.
How surprised I am today that no one thought that that was wrong."

"Even today when I turn on a light I'm amazed.
I remember reading by candlelight and carrying in buckets of water for a bath.
As a child, I couldn't even imagine in my wildest dreams that we would have
a telephone, television, the airplane, much less land on the moon."

"Yes, one can learn how to be frugal.
I've lived through six wars, and I remember rationing of food,
starvation for some, and fear of what you might not have tomorrow."

"In my day, women couldn't push a button and make things happen.
Today, women's lives are more important.
They have less physical stress but more emotional stress."

"Years ago I had a temper.
I used to watch other people, until I started watching my own self.
My advice to the young people is to
remember that nobody studies your part like you."

EVERY MORNING, BEULAH MAE WALKS TWO MILES. OVER THE YEARS SHE HAS NOTICED THAT PEOPLE ARE TOO BUSY TO SAY HELLO
AND THAT BOTHERS HER. BORN IN MISSISSIPPI, SHE IS A WIDOW WHO WAS MARRIED FORTY-THREE YEARS. HER EYESIGHT IS FAILING
RAPIDLY, YET WITH THE AID OF A NEW COMPUTER SHE CAN STILL READ. A MOTHER OF ONE, GRANDMOTHER OF FOUR, AND GREAT-GRANDMOTHER
OF THIRTEEN, SHE WAS A FIRST-GRADE TEACHER AND NOW TEACHES BIBLE TO THE INTERNATIONAL WOMEN'S CLUB EVERY WEDNESDAY.
ANYTHING IS POSSIBLE IF SWEET-NATURED BEULAH MAE ONCE HAD A TEMPER. SHE IS NINETY-EIGHT YEARS OLD AND LIVES IN EDMOND, OKLAHOMA.

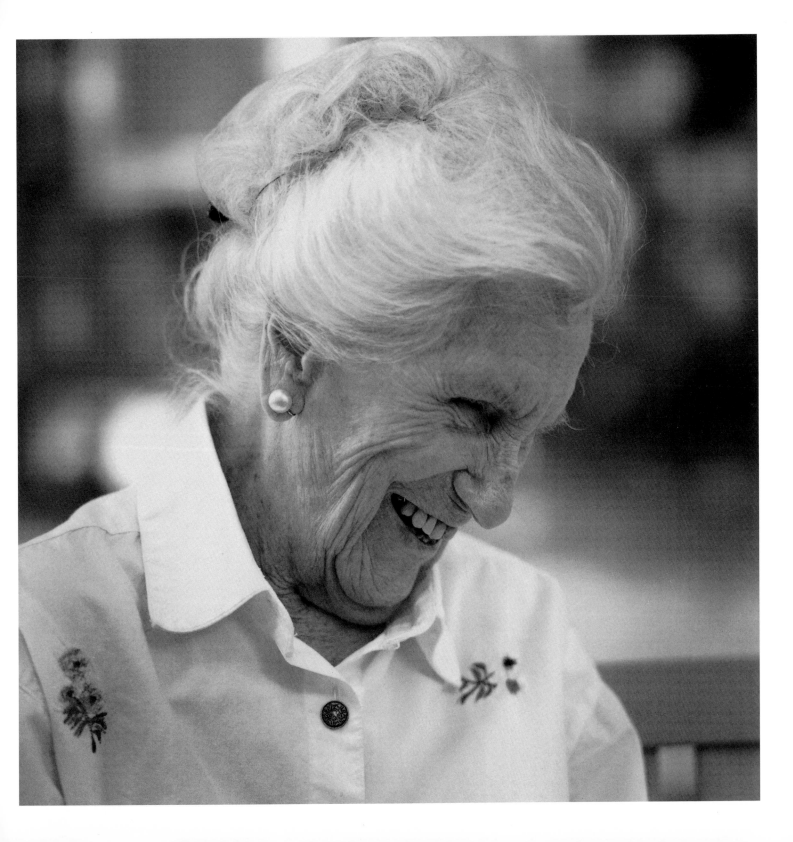

Daisy Trexler

"I was a grown woman the first time I met my mother, who had put me in an orphanage.
The first thing I asked her was, 'Who is my father?'
She pointed out the window and said, 'If he passed me walking down the street I wouldn't know him.
I had to make money somehow.'"

"As a young girl, I planned on making up for my lack of pedigree by marrying right.
The day I got married, I wet my pants, and it wasn't because I was laughing.
I married right into a lot of trouble. He was emotionally abusive, and I was afraid to leave."

"The only thing I ever fought for was my virginity.
Then I fought for independence from the man who took it from me."

"Did you ever start a book and not want to finish it?
You dislike the characters and don't care how the story turns out.
That's how I felt about my life. I put that book down and started a new one."

"Today women are smarter.
They make money, have independence, and live in a society that is more forgiving."

"Because I had such a tough start, God is making sure I have a good ending."

A LOVING FAMILY ADOPTED DAISY WHEN SHE WAS TEN YEARS OLD. THEY NICKNAMED HER SUNNY, AND IT'S EASY TO SEE WHY. OVER THE YEARS, SHE HAS BEEN A PIANO TEACHER AND SINGER. SHE WAS MARRIED FOR THIRTY-FIVE YEARS BEFORE THE ABUSE TURNED PHYSICAL AND SHE WAS FORCED TO LEAVE. TODAY, LIVING IN A RETIREMENT HOME, SHE COUNSELS WOMEN AT THE LOCAL SHELTER AND CONTINUES TO GIVE PLEASURE TO THOSE AROUND HER BY SINGING IN THE SUNDAY CHOIR. WRITING HER LIFE STORY FOR HER CHILDREN IS DAISY'S PROUDEST ACCOMPLISHMENT. THIS MOTHER OF FOUR, GRANDMOTHER OF SIX, AND GREAT-GRANDMOTHER OF NINE IS EIGHTY-EIGHT YEARS OLD AND LIVES IN CHARLOTTE, NORTH CAROLINA.

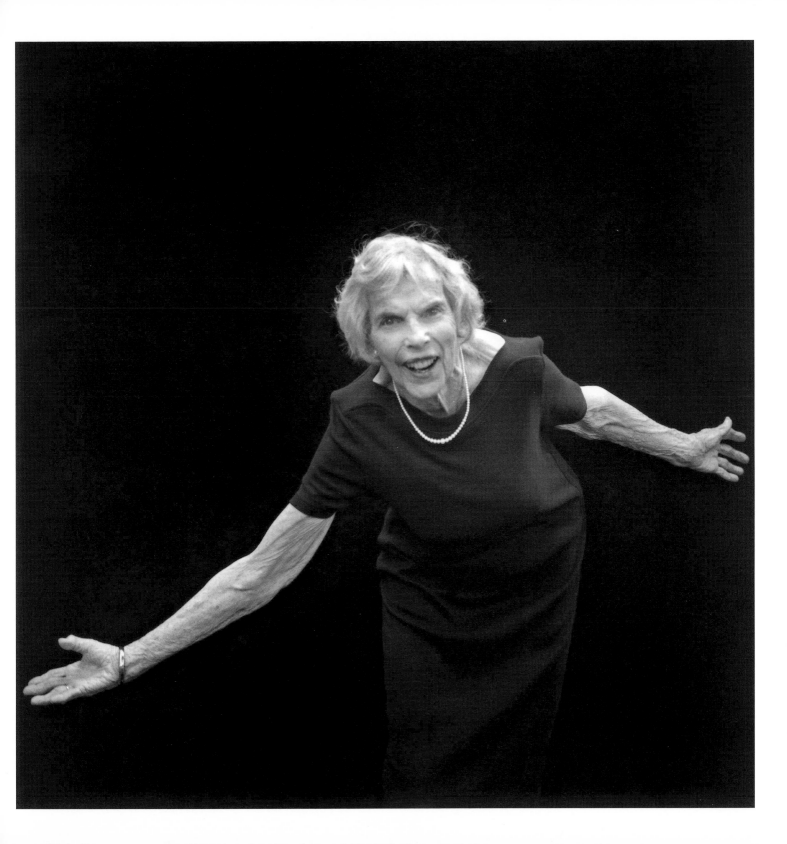

Nancy Lerner

"From the day I was born I was the light of my mother's life. You bet I was spoiled, but,
in a good way—hugs, kisses, compliments. Sing for me, dance for me . . . I was perfect in her eyes.
I understood cause and effect early. Because of that I rarely needed to be disciplined."

"Of course the world didn't see me as perfect. I am eccentric and people either
love me or hate me. I can be a little too outgoing and a little too loud.
It's ironic that coming from so much love, I ended up with self-esteem problems."

"I battled an eating disorder for years and have recently overcome it.
Everyone wants to be liked. I don't know how to be someone else and I will
never understand people who think everyone should be just like them."

"Accepting a compliment was always an embarrassment to me.
Today I see every kind word as a gift."

"A few things have shifted but nothing's been lifted, at least not yet.
When I was younger and heard older women saying they felt like sixteen,
I would laugh at them. Guess who's saying the same thing now?"

"For me dressing is an art form. I jump out of bed every morning,
thrilled to go to work. I'm a retail therapist and makeover artist. In a chaotic world
I'm able to help people feel like a million dollars on a regular basis. That has changed my life."

"I found out that if I want my children to listen to my advice I start by saying,
'I might be wrong.' You should see how they pay attention to that."

AT SIXTY YEARS OLD, NANCY WANTED TO BE A BRIDE AGAIN. ON IMPULSE SHE BOUGHT A LONG WHITE GOWN THAT WOULD HAVE BEEN FAR
TOO TRADITIONAL FOR HER AS A YOUNG WOMAN. RIDING A MOTORCYCLE TO THE CEREMONY WAS JUST PART OF THE FUN. THE GROOM,
HER HUSBAND OF THIRTY-FOUR YEARS, IS SURPRISED AT NOTHING. OUTRAGEOUS, FUN LOVING AND KIND, SHE IS THE MOTHER OF TWO CHILDREN
AND A FORMER CLOTHING DESIGNER AND BOUTIQUES STORE OWNER. EVERY DAY WITH SLEIGHT OF HAND SHE MAGICALLY TRANSFORMS
MANY DUCKLINGS INTO SWANS. NANCY WAS BORN IN NEW YORK AND NOW LIVES IN CHARLESTON, SOUTH CAROLINA.

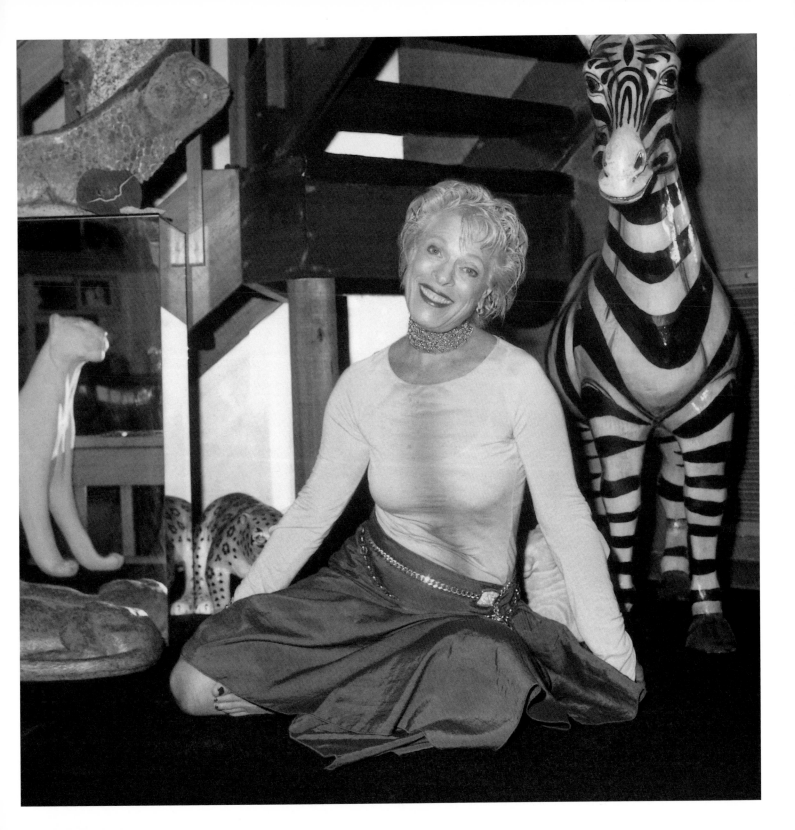

Gertie Box

"Make no mistake, my parents wanted a boy and they let me know it. My mother, who had a stroke
right after I was born, became an invalid and unfortunately had no more children. My father would tease me
about the limitations of being a girl—he didn't understand how personally I took his words."

"One of the things I would often hear was, 'You look just like your mother.' My mother weighed
two hundred pounds and I didn't want to look anything like her. I became an athlete."

"I'm not bragging when I tell you that I win every swimming race I enter. You see,
I've outlived all the competition. If I want a ribbon all I have to do is get from one side of the pool to the other."

"This may sound silly, but it's true. My father, who was a minister, said the only way he and my mother
could get into heaven was for me to have a lot of children.
He believed that by your fruits you are known, and I was a ripe peach."

"The first four years of my marriage I lost thirty-five pounds while my husband gained one hundred.
Back then no one talked about domestic abuse. For twenty-five years I was spit at,
punched, and swung around by my ponytail. No one believed me—not the police or the priest.
In all honesty, twenty children wouldn't have been as much trouble as that one husband."

"The generation that followed mine set me free. Women finally started speaking up and sticking up for themselves.
I realized how abnormal my life was and ran screaming from a twenty-five year marriage. The only regret I have now
is that I didn't leave earlier. Years later, after he died, I found out he had abused several of our children as well."

"My advice to the next generation is don't stop moving, always be
learning, and you won't be bored. If you want to get high, use some adrenaline."

GERTIE IS DELIGHTFULLY ECCENTRIC. HER CLOSET LOOKS LIKE A HALLOWEEN COSTUME STORE AND HER HOME A FEAST FOR THE EYES WITH MIRRORED
CEILINGS, BLACK LIGHTS, AND FLEA MARKET ART. SHE IS THE MOTHER OF EIGHT CHILDREN, A SURFER, SKYDIVER, AND LICENSED PILOT. SHE SKYDIVES OFTEN,
LOVING THE THRILL OF LANDING ON HER OWN FEET. GERTIE HAS A PhD IN SOCIOLOGY AND IS AN INTERFAITH MINISTER WHO IS NOW
STUDYING FOR HER DOCTORATE IN DIVINITY. SHE HAS EIGHTEEN GRANDCHILDREN, TWO GREAT-GRANDCHILDREN, AND ONE GREAT-GREAT-GRANDCHILD.
GERTIE HAS A NINETY-YEAR OLD LOVER BUT PREFERS NOT TO MARRY AGAIN. SHE IS EIGHTY-THREE YEARS OLD AND LIVES ON LONG ISLAND.

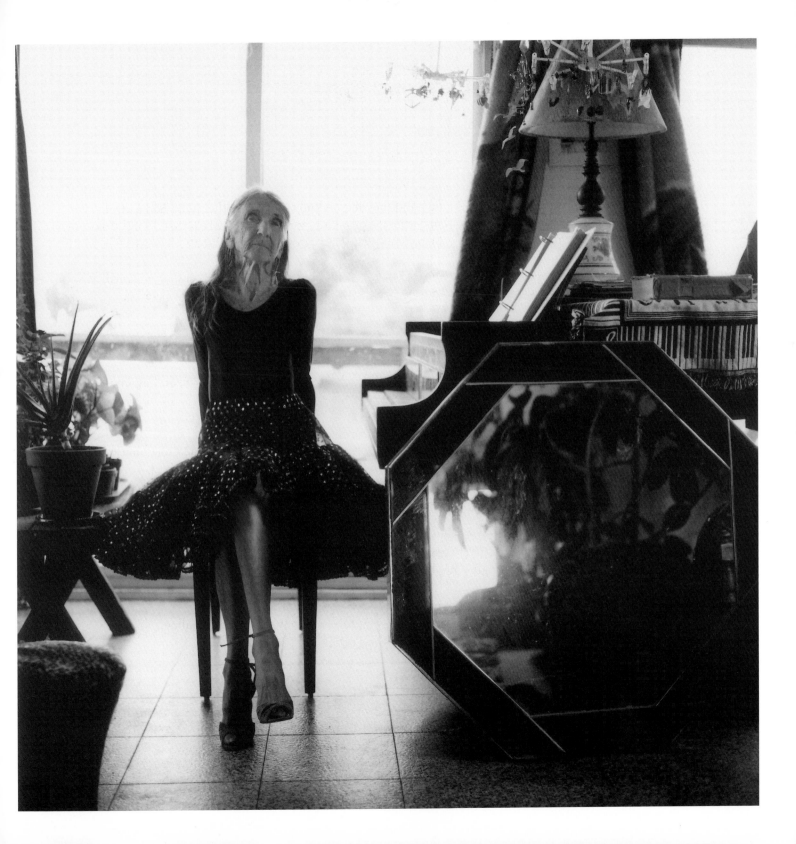

Acknowledgements

Thank you so very much to all the special people in my life who encouraged me
and provided the needed support to help me complete this journey:

To my grandmothers, Mary Boyle for her gift of laughter and never giving up,
trying to perfect that already perfect apple pie, and Valeria Kennedy, for being an eloquent lady
who went back to school in her seventies and learned to speak Spanish.
I thank them for giving me unconditional love and for showing me how good life can get.

To Mary Fitzgerald, my mother-in-law, Patricia Lennon and Margaret Fischer, my aunts,
thank you for living life with faith, for showing me the meaning of stoicism and teaching me by example
how to handle life with a sense of humor.

To my friends who helped me find the remarkable women in this book—without you,
my dream would never have come to pass: Sarita Solomine, Susan Mahan, Marilyn Pagano, Paula Robinson,
Celeste McGeehan, DeDe Charnok, Rosalind D'Achille, Mike Stack, Joanne Maguire, Eileen Winnick,
Louise Keim, Cynthia Salzman, Andy Reardon, James Pitcher, Michael Pitcher, Richard Klima,
Walter Beach, Robert Coury, Carol Petisi, Elena Foster, Caddie Harper, Leslie Young, Susan Hendee,
Lynda Golm, Ted Barnes, Sharon Barnes, June Rosetti, Ginger Propper, Robin Cambell,
Catherine Johnson, Connie Pecoraro, Michelle Toth, Mary Lou McGloughlin, Tara Downey,
Michelle Knight, Judy Isaman, Maria DeGeus-Sobkowiak, Traci Arney, and Bill Wescott.
And to Jodi Weiss for her tireless efforts and enormous enthusiasm.

To all the amazing women and some really wonderful men at *Frank About Women*
for their insights and creativity. Special thanks to Beth Kosuk, Leslie Messick, Trisha Hope,
Barbara Wilson, Venica Powell, Jason Gamble, Carrie McCament, Jennifer Ganshirt,
Siobhan Olson, Colleen Brannan, Carrie O'Sullivan, Marti Bledsoe, Ann Boger, Taylor Bryant,
Caryn Harbour, Hope Schultz, Dina Keenan, Stephanie Ouyoumjian, Elizabeth Lee Lawley,
Kate Holmes, Wendy Parker, Christine Brandt, and Carol Sterling.

To Tom Payton and Judy Long at Hill Street Press for their caring and guidance.

To my daughters Kerri and Jackie for constantly encouraging their mom.
And finally, to my husband John, for always believing—even when I didn't.